MISSISSIPPI
SIGNS

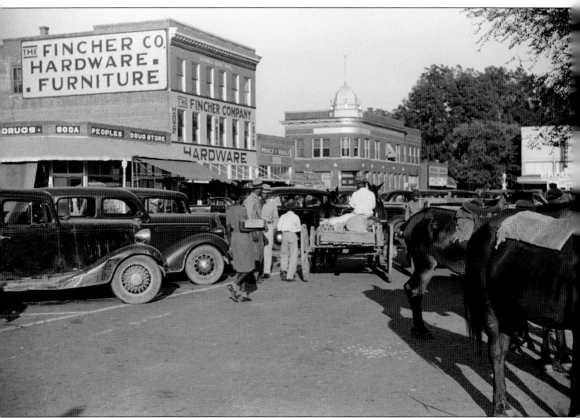

LEXINGTON, MISSISSIPPI, 1939. This photograph shows Lexington town square in Holmes County on a Saturday in October 1939. The Fincher Hardware sign is clearly visible and can still be seen today. The photograph is by Marion Post Walcott, best known for producing over 9,000 photographs for the Farm Security Administration (FSA) from 1939 to 1942. FSA photographers documented the impact of the Great Depression and World War II on American life. (Prints & Photographs Division, Library of Congress.)

FRONT COVER (CLOCKWISE FROM TOP LEFT): Weidmann's, Meridian, in 2022; Dockery Farms, Sunflower County, 2019; Sun-N-Sand Motor Hotel, Jackson, 2021; Tupelo "First TVA City" sign, Tupelo, 2019; Southern Cafe, Itta Bena, 2019. (Author's collection.)

UPPER BACK COVER: Brent's Drugs, Jackson, 2022. (Author's collection.)

LOWER BACK COVER (FROM LEFT TO RIGHT): New Roxy Theatre, Clarksdale, 2019; Red Hot Truck Stop, Meridian, 2019; New Deal Tobacco and Candy Company, Greenwood, 2017. (Author's collection.)

MISSISSIPPI SIGNS

STEVEN MANHEIM

ARCADIA
PUBLISHING

Published by Arcadia Publishing
Charleston, South Carolina

Printed in the United States of America

Library of Congress Control Number: 2022945135

For all general information, please contact Arcadia Publishing:
Telephone 843-853-2070
Fax 843-853-0044
E-mail sales@arcadiapublishing.com
For customer service and orders:
Toll-Free 1-888-313-2665

Visit us on the Internet at www.arcadiapublishing.com

*This book is dedicated to the memory of my
parents, Ilene and Bill Manheim.*

CONTENTS

ACKNOWLEDGMENTS

Thank you to Kelley Richards for constant encouragement, support, assistance, knowledge, and editing skills in making this project become a reality; Pass Christian Books for their confidence in this book; Mississippi Heritage Trust for the saving and renewal of all places meaningful to Mississippi; and the Mississippi Department of Archives and History (MDAH) for extensive and detailed historic resources. Unless otherwise noted, all photographs are by the author.

INTRODUCTION

Signs are all about advertising. Advertising sends a message. Signs provide messages about products, services, and businesses. Signs reflect the times they were created. But most of all, signs tell stories. These old signs in Mississippi were stories, many long forgotten, waiting to be told.

These are the stories of the people who created businesses and sold products that shaped the history of Mississippi. They are also the stories of the people who called Mississippi home.

When I first began my journeys through Mississippi, I immediately noticed the large amounts of vintage signs. Many of these signs remain in great condition, retaining structural integrity with original construction materials and paint still readable. Only time and the effects of rust and weathering have stripped many signs of their original veneer. They remind me of a simpler time when America was still based on local businesses. These signs placed me back into those earlier times.

These old signs of Mississippi were witness to changing times. They were the backdrop to people's lives through the Roaring Twenties, two world wars, the Great Depression, the Great Migration, the civil rights era, the Vietnam War, and the social changes of the 21st century.

These signs have remained silent reminders of the passage of time. They have weathered through the years and changes—but they were also a part of the changes. Country stores, drugstores, hardware stores, restaurants, and theaters not only provided services and products, but also served as community gathering spots for many decades and generations. Their signs defined the times and landscape of not only Mississippi, but the entire nation.

Mississippi was at the epicenter of the civil rights movement in the 1960s, a crucial time of change in America. These signs bear witness to the times, which include James Meredith's March Against Fear, culminating in the state's largest civil rights rally at the state capitol, the Freedom Rider arrests at the Greyhound station in Jackson, the lunch counter sit-in protests at the Woolworth's in Jackson, the Biloxi Beach wade-in protests, the Greenwood civil and voting rights protests, and the business boycotts in Port Gibson.

The Great Migration of African Americans to the North, which continued from the early 20th century into the 1970s, left many once-vibrant towns with rows of empty stores. Many of these towns never recovered, leaving abandoned buildings and storefronts with original signage.

In my photography career, I have always been fascinated with historical photographs. I was especially drawn to the definitive photographs by the Farm Security Administration–Office of War Information between 1935 and 1944. This agency sent photographers throughout the country to document American life and the effect of the Great Depression and World War II. The list of FSA photographers included Walker Evans, Dorothea Lange, Gordon Parks, Arthur Rothstein, and Marion Post Walcott. The photographs by Marion Post Walcott in the Mississippi Delta remain important documents of the state in that era.

The iconic photographs from the civil rights era by Bob Adelman, Bob Fitch, Danny Lyon, and Ernest Withers were also influential.

My introduction to Mississippi began through my interest in the blues, specifically when I met the late blues great Robert Lockwood Jr. in 1998 in Cleveland, Ohio. Lockwood was from Turkey Scratch, Arkansas, and was the stepson of Delta blues legend Robert Johnson. He was a direct link to Johnson and the only student to have learned directly from him.

Lockwood traveled and played guitar at juke joints and on street corners in the Mississippi Delta in the 1930s with harmonica great Sonny Boy Williamson II. In 1941, Lockwood and Williamson were the first live blues performers heard on the radio across the Delta, on *King Biscuit Time* on KFFA in Helena, Arkansas. I was fortunate to photograph Lockwood and other blues legends at many venues during the final years of his career.

In 2016, I had the opportunity to visit the Mississippi Delta, the traditional birthplace of the Delta blues. I traveled across the area to visit the hometowns of these musicians I had photographed. This led to the publication of my first book, *Blues Musicians of the Mississippi Delta*, in 2019 with Arcadia Publishing. While I was there, I discovered many old signs that remained in the area. I was amazed at the excellent condition of these signs, which were never meant to be permanent.

Without proper maintenance or restoration, these old signs are fading into history. While traveling, I realized the time was right to document these fleeting landmarks before they were gone. On subsequent trips, I toured each section of the state, from the Delta, Hill Country, Piney Woods, Capital/River, and Gulf Coast.

A large amount of remaining signage in Mississippi is in stark contrast to the relatively small amount that is still in my native Ohio. It was refreshing to see these forgotten signs I remember from my youth. They are reminders of when Mississippi and America had a personal, local identity. They evoke a lost nostalgia disappearing from the American landscape.

Over six years, I crisscrossed the state several times looking for well-known and obscure locations. I visited all the major cities, including Jackson, Gulfport, Hattiesburg, Greenville, Meridian, Tupelo, and Vicksburg. I traveled through many smaller towns like Belzoni, Carrollton, Ellisville, Liberty, Mount Olive, Friars Point, and Winona. Through these trips, I compiled an extensive portfolio of signs. With the passage of time, these signs are rapidly fading into history. The time was right for a permanent document of these disappearing landmarks.

Famous landmark signs that were saved from destruction include the Sun-N-Sand Motor Hotel in Jackson, Red Hot Truck Stop in Meridian, and King Edward Hotel in Jackson. Restored signs that retain their original integrity include Biedenharn's Candy Company in Vicksburg, the Alamo Theatre in Jackson, and Dockery Farms in Sunflower County. Faded ghost signs on the sides of buildings were always special, especially Coca-Cola and other well-known brands. These signs are works of folk art that provide a glimpse into the past.

As I traveled for the first time into new Mississippi towns, I was eager with anticipation, hoping to breathe in a slice of Americana if only for a brief moment. These signs are reminders of the American spirit and entrepreneurship. Stories of people who struggled through adversity. They represent the dreams of immigrants who came to America to pursue the American dream. They also represent the struggles of African Americans, from segregation through the civil and voting rights movements. All these signs represent the challenges and triumphs of the spirit.

These signs tell a history of the people and culture of Mississippi. They represent what once was and what can still be.

One

HISTORICAL SIGNS
OF MISSISSIPPI

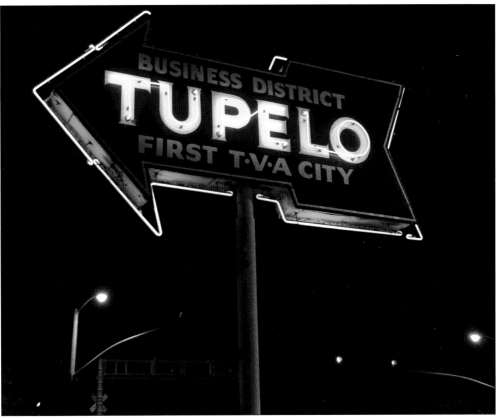

FIRST TVA CITY SIGN, TUPELO, 2019. Tupelo made history in 1934 when it became the first city to purchase electrical power from the new Tennessee Valley Authority (TVA). The TVA was a hydroelectric power initiative by the federal government that provided low-cost electricity to rural Mississippi and six other southern states. This large directional neon sign, located at the city's Crosstown intersection, was installed in 1945 by the Balton Sign Co. of Memphis. The sign was listed as a local landmark in 2011.

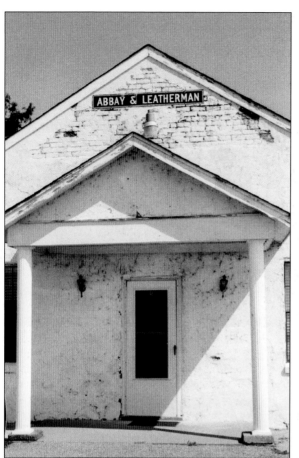

ABBAY & LEATHERMAN, ROBINSONVILLE, 2016. Abbay and Leatherman is one of the oldest and largest cotton plantations in the Mississippi Delta. Richard and Anthony Abbey purchased land from the Chickasaw Nation in 1832 to create a prosperous farm. More than 450 families lived and worked here during its peak. Blues legend Robert Johnson lived in a levee shack as a young boy with his family in a section known as Polk Place.

BARQ'S ROOT BEER, BILOXI, 2022. Edward Charles Edmond Barq Sr. invented Barq's Root Beer in a small, wood-framed building in Biloxi. Barq was a sugar chemist who studied soft drink formulation. In 1898, he moved from New Orleans to Biloxi and constructed the Biloxi Artesian Bottling Works on Keller Avenue. It was here where he experimented with soft drink formulas to produce his root beer. Barq's operated at this location until 1936 before moving to a larger plant in Biloxi.

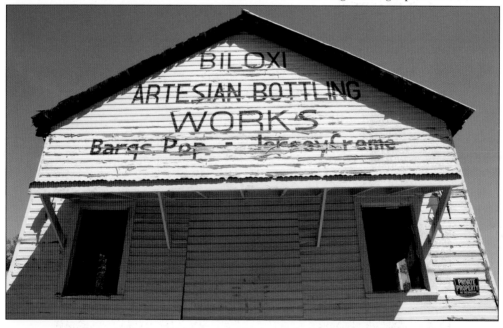

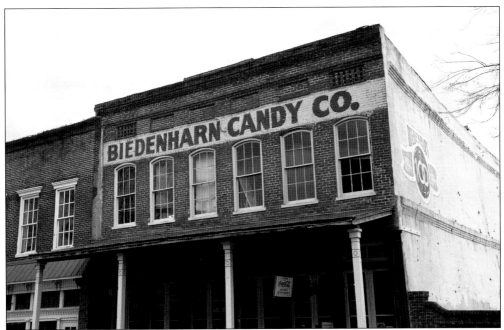

BIEDENHARN CANDY COMPANY, VICKSBURG, 2022. The Biedenharn Candy Company started serving Coca-Cola, a new fountain drink made of syrup and carbonated water, at the soda fountain counter in 1890. Joseph Biedenharn saw the potential for sales of Coca-Cola in rural areas without access to fountains. In 1894, he began bottling Coca-Cola on Washington Street to become the first Coca-Cola bottler. On approval from Coca-Cola founder Asa Candler, Biedenharn sold bottled Coca-Cola in rural Mississippi. Through bottling, Biedenharn created a new marketing concept for Coca-Cola and established the start of an independent network of franchise bottlers. Later, he and his brothers acquired franchises to bottle Coca-Cola in Mississippi, Louisiana, and Texas. In 1979, the Biedenharn family bought this c. 1888 building and renovated it into the Biedenharn Coca-Cola Museum. The family donated the building to the Vicksburg Foundation for Historic Preservation.

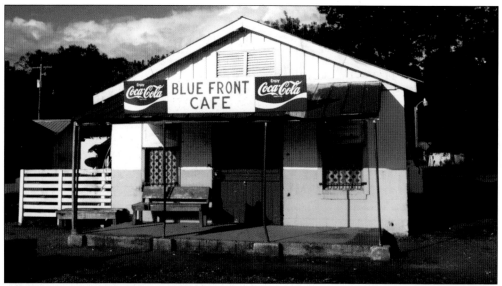

Blue Front Cafe, Bentonia, 2017. The Blue Front Cafe is the oldest surviving juke joint in Mississippi. Opened in 1948 by Carey and Mary Holmes, the café has been owned by Jimmy "Duck" Holmes since 1970. It was once a gathering spot for field workers in Yazoo County. Bentonia blues is a distinct style of minor-key blues, made notable by Skip James and Jack Owens. Blues musicians Sonny Boy Williamson II, Henry Stuckey, and James "Son" Thomas played here.

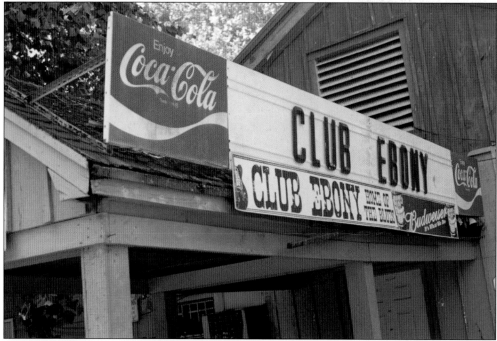

Club Ebony, Indianola, 2016. Club Ebony was one of the South's most important African American venues. Opened in 1948 by Johnny Jones, it was a stop on the "chitlin' circuit" for many blues legends, including B.B. King, Little Milton, Ray Charles, Howlin' Wolf, and Albert King. In 1974, the club was purchased by Mary and Willie Shepard, with Mary running the club for 34 years. B.B. King bought the club in 2008, preserving it as a cultural landmark.

BORROUM'S DRUG STORE, CORINTH, 2018. Borroum's Drug Store was the oldest continuously operating drugstore in Mississippi until the pharmacy closed in 2021. Founded in 1865 by Confederate surgeon Dr. Andrew Jackson "Jack" Borroum, the store is Corinth's oldest business. It has been operated by the Borroum family since its opening. The original 1939 fountain, the oldest in Mississippi, remains in operation. Borroum's is famous for slugburgers, a Depression-era food made of ground pork, soy flour, and spices that were originally sold for a nickel.

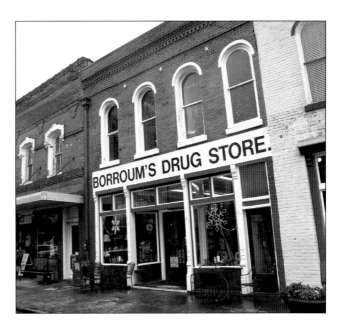

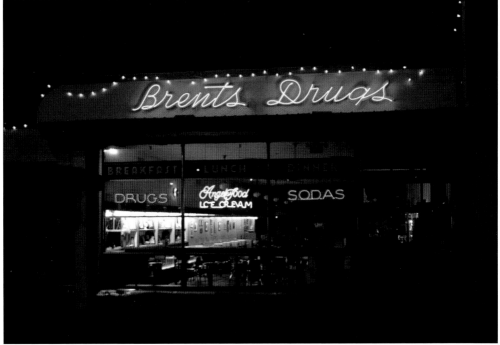

BRENT'S DRUGS, JACKSON, 2022. Dr. Alvin Brent founded Brent's Drugs in Jackson's Fondren neighborhood in 1946. Brent's opened in Morgan Center, Mississippi's first shopping center, later renamed Woodland Hills Shopping Center. Brent operated the pharmacy and soda fountain until it was sold in 1977. In 2009, Brad Reeves bought the business to focus on the restaurant. The store was renovated in 2014, retaining the fountain and original Art Deco atmosphere. A scene from the 2011 movie *The Help* was filmed here.

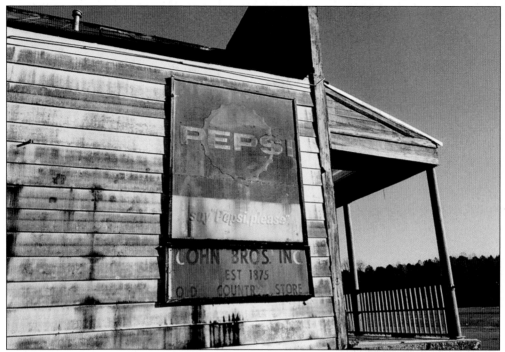

COHN BROTHERS GENERAL MERCANTILE, LORMAN, 2018. The Cohn Brothers General Mercantile was one of America's oldest general merchandise stores in continuous running operation. The store was founded in 1890 by French immigrants Lehman Cohn, with older brothers Heiman and Joseph L. Cohn; he eventually became sole owner, and the store remained in the Cohn family until 1965, with later owners closing it in 1996. Today, it operates as the Old Country Store restaurant on Highway 61 in Jefferson County.

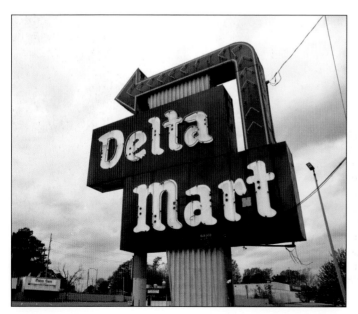

DELTA MART, JACKSON, 2022. Delta Mart Shopping Center was completed in 1958 by developer Dorsey J. Barefield. Located on Highway 49 north, now Medgar Evers Boulevard, Delta Mart was northwest Jackson's only shopping center and the first in Mississippi to have piped-in music in all stores and exterior areas. Original tenants included Acme Cleaners, Akers Barber Shop, Ben Franklin Store, Jitney Jungle, McClinton Department Store, and Southwest Drug Company.

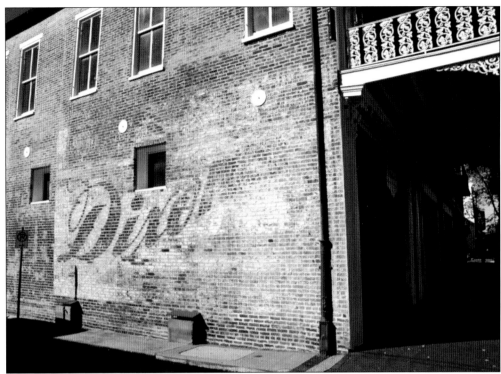

DIXON BUILDING, NATCHEZ, 2018.
The Dixon Building is among the most
architecturally significant structures
in downtown Natchez. The building
was constructed by Scottish immigrant
Robert Smith Dixon between 1866
and 1872. An advertisement from
1856 describes the firm's services as
"House, Sign and Ornamental Painters,
Imitators of Woods and Marbles,
Gilders, Glaziers, Paper Hangers, Wall
Colorers." The building is listed in the
National Register of Historic Places.

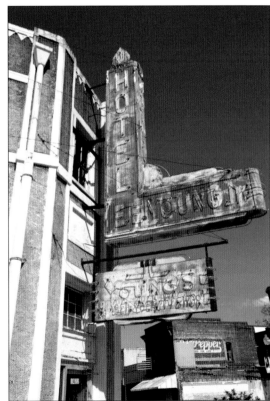

E.F. YOUNG HOTEL, MERIDIAN, 2022.
The E.F. Young Jr. Hotel was the first
hotel open to African Americans in
Meridian during the segregation era.
Businessman E.F. Young Jr. opened
the hotel with a barber and beauty
shop in 1946. Leontyne Price, Ella
Fitzgerald, Martin Luther King Jr., and
the Harlem Globetrotters were among
the distinguished guests. The hotel was
a meeting place during the 1960s civil
rights era and remained open until 1978.

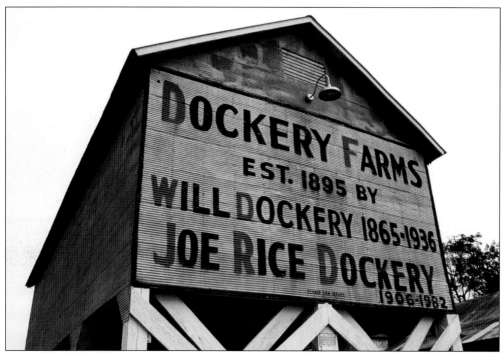

DOCKERY FARMS, SUNFLOWER COUNTY, MISSISSIPPI, 2019. Dockery Farms was founded in 1895 by Will Rice Dockery when he purchased land bordering the Sunflower River. By the 1920s, the farm grew to over 6,000 acres, making Dockery one of the most important plantations in the Delta. His son Joe Rice Dockery inherited the farm in 1936. Charley Patton, "Founder of the Delta Blues," relocated to Dockery with his family in 1900, where he played at the farm in the 1920s. Patton's influence included Son House, Robert Johnson, Howlin' Wolf, Tommy Johnson, and Roebuck "Pops" Staples. At its peak, Dockery had two elementary schools, a post office, a railroad depot, a blacksmith shop, and a commissary. Dockery housed 400 tenant families who migrated to the region for work. The seed house with a painted sign, built around 1930, and service station, built around 1935, remain among the intact buildings.

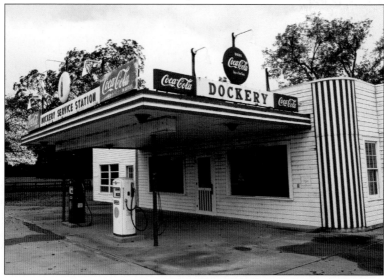

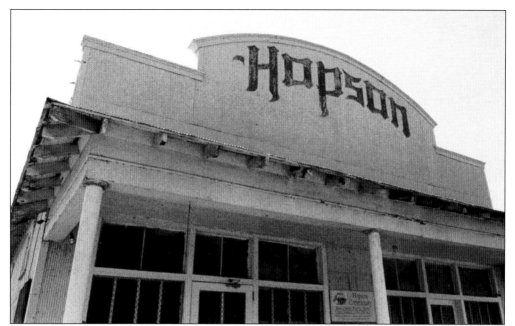

Hopson Farms, Clarksdale, 2016. The Hopson Planting Company was the first to harvest cotton entirely by machine in 1944. International Harvester tested and developed tractor-mounted cotton pickers from 1935 to 1944 at Hopson. This revolutionized the cotton industry and was a primary reason for the Great Migration of African Americans from the South to northern cities. This technology greatly diminished the need for manual labor and marked the decline of the sharecropping system. Blues pianist Joe Willie "Pinetop" Perkins was a tractor driver at Hopson in the 1940s. The Hopson Commissary building, above, built around 1905, served as a grocery store, meeting place, and farm office and is now an event venue.

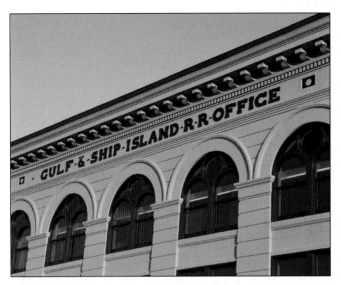

GULF & SHIP ISLAND RAILROAD OFFICE BUILDING, GULFPORT, 2019. The Gulf & Ship Island Railroad was constructed to transport southern yellow pine from Jackson to Gulfport, through Hattiesburg, with branch lines to Laurel and Columbia. The three-story building was erected in 1903. The railroad was bought by the Illinois Central Railroad in 1925. The building was restored by the Mississippi Power Company and is now used for the Gulf Blue Initiative by the University of Southern Mississippi.

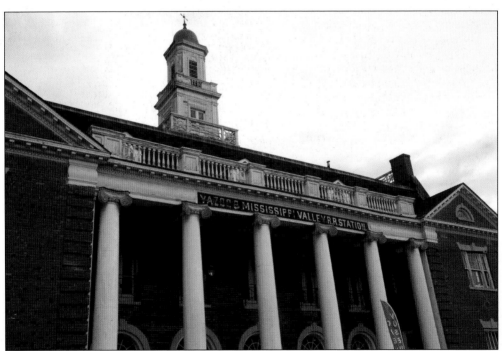

OLD DEPOT MUSEUM, VICKSBURG, 2017. Completed in 1907, the Yazoo & Mississippi Valley Railroad (Y&MV) Depot was open to passengers until 1932. Designed by the Illinois Central, which owned the Y&MV, the depot continued as railroad offices until 1977. The Y&MV operated as part of the Illinois Central until it officially merged into it in 1946. The depot was flooded by the Mississippi River in the Great Flood of 1927 and the flood of 2011.

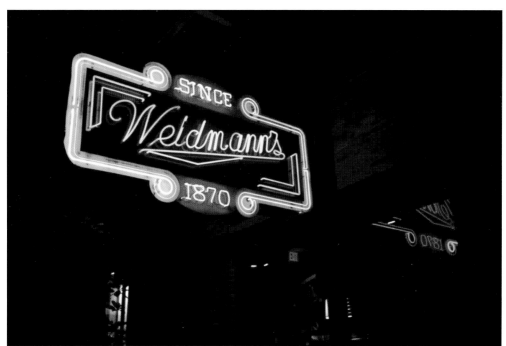

WEIDMANN'S, MERIDIAN, 2022.
Weidmann's is the oldest restaurant in Mississippi and the oldest surviving business in downtown Meridian. In 1870, Swiss immigrant Felix Weidmann established the restaurant. In 1923, grandson Henry Weidmann moved to the present location in the historic 1880 building at Twenty-Second Avenue at Fourth Street. Famous for black bottom pies and peanut butter crocks, the restaurant was operated by the Weidmann family into the 1990s.

MAYFLOWER CAFE, JACKSON, 2022.
The Mayflower Cafe has been a cultural landmark in Jackson since the Great Depression. Opened in 1935 by Greek immigrants George Kountouris, John Gouras, and John Dorizas, it is Jackson's oldest operating restaurant. Jerry Kountouris continued the family tradition into the 2020s. Movie scenes filmed at the restaurant include *Ghosts of Mississippi* in 1996 and *The Help* in 2011. The original sign was installed by the Mississippi Neon Sign Company.

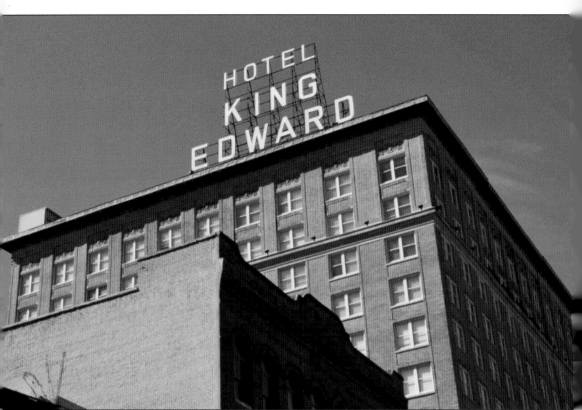

KING EDWARD HOTEL, JACKSON, 2021. The King Edward Hotel opened in 1923 as the Edwards Hotel. The Edwards Hotel replaced the Edwards House, built by Maj. R.O. Edwards in 1867. Designed by New Orleans architect William T. Nolan, the 12-story hotel had 300 rooms with a ballroom and staircase. It was the temporary site for Okeh Records in 1930 and American Record Corporation in 1935 to record blues musicians Bo Carter, Robert Wilkins, Joe McCoy, and the Mississippi Sheiks. In 1954, R.E. "Dumas" Milner purchased the hotel, renaming it the King Edward with renovation and expansion. The hotel was a social institution in Jackson but closed in Mississippi's changing cultural landscape in 1967. It remained vacant for 40 years. In 2009, a renovated King Edward Hotel, with a refurbished sign, became the Hilton Garden Inn, with upper-floor luxury apartments.

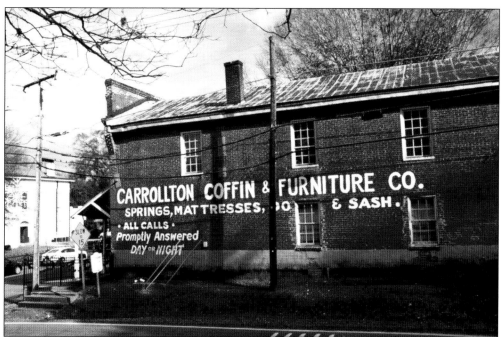

MERRILL'S STORE, CARROLLTON, MISSISSIPPI, 2018. The Merrill House building was the first brick store in Carrollton, constructed in 1834, and the only surviving 19th-century building on the block. The first documentation of the present structure is in a deed from around 1860. The Carrollton Coffin Co. began in 1901 by selling coffins and providing horse-drawn hearses. Around 1915, Robert Gray and H.E. Merrill operated the Carrollton Coffin and Furniture Company. The sign was made for the 1969 movie *The Reivers*.

PO' MONKEY'S, MERIGOLD, 2016. Po' Monkey's was one of the last remaining rural juke joints to survive into the 21st century. Located in Bolivar County, the nightspot was opened by Willie "Po Monkey" Seaberry in an old sharecropper shack in 1963. It became popular with students and a destination for blues tourists in the 1990s. Po' Monkey's closed in 2016 with Seaberry's passing, marking the end of an era.

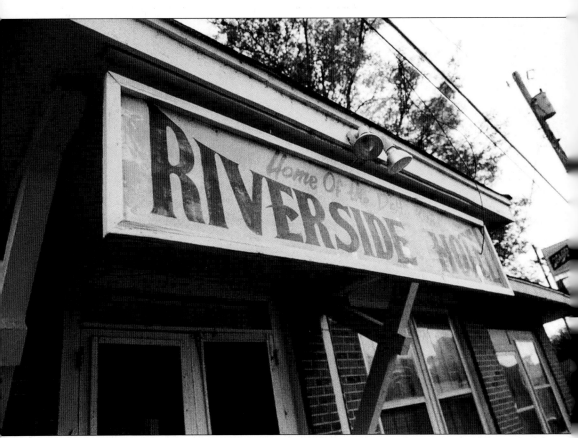

RIVERSIDE HOTEL, CLARKSDALE, 2016. Steeped in blues history, the Riverside Hotel first opened as a hospital for African Americans. Opened in the 1920s under two different names, it became the G.T. Thomas Afro-American Hospital in the early 1930s. Blues singer Bessie Smith was taken here after her fatal car crash on Highway 61 in 1937. The hospital was converted into a hotel with 20 rooms by Z.L. Ratliff Hill in 1944. Her son Frank "Rat" Ratliff took over the business in 1997 until his death in 2013. Her granddaughters Sonya Ratliff Gates and Zelena Ratliff continue the hotel's legacy. Guests have included Sam Cooke, Duke Ellington, John Lee Hooker, Muddy Waters, and Sonny Boy Williamson II. Ike Turner and his Kings of Rhythm rehearsed "Rocket 88," cited as the first rock-and-roll record, in the hotel's basement in 1950. The building was placed on the 11 Most Endangered Places in America list in 2021 by the National Trust for Historic Preservation. In 2022, the hotel received grants from the National Park Service through an African American civil rights grant for restoration and preservation.

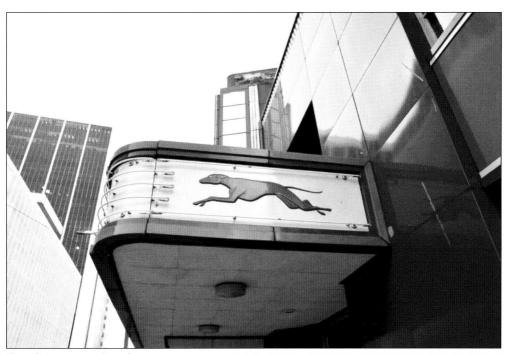

OLD GREYHOUND BUS STATION, JACKSON, 2021. Jackson made history when the Freedom Riders arrived at the Greyhound station to challenge racial segregation in May 1961. When they arrived from Montgomery, Alabama, and tried to use the station's facilities, they were arrested for breach of peace. As a result of the Freedom Rides, the Interstate Commerce Commission mandated an end to segregation in interstate transit terminals in September 1961. The station was built around 1936 and designed by architect W.S. Arrasmith.

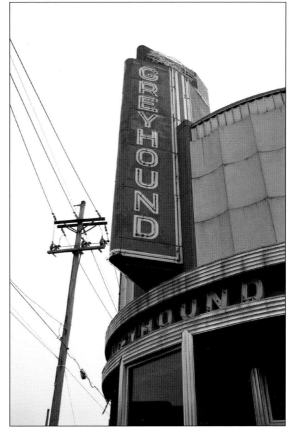

OLD GREYHOUND BUS TERMINAL, CLARKSDALE, 2019. The old Greyhound bus terminal in Clarksdale was integral in the desegregation of bus stations in Mississippi. Clarksdale civil rights activist Vera Mae Pigee, with her daughter Mary Jane, were harassed in the white waiting section, sparking protests that led to the desegregation of the station in December 1961. The terminal was built around 1936 by W.S. Arrasmith and renovated in 2001.

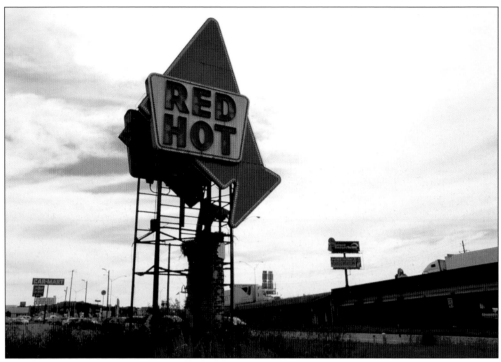

RED HOT TRUCK STOP, MERIDIAN, 2019. The Red Hot Truck Stop was a classic slice of Americana and one of the last great truck stops. Opened in 1955, the eatery welcomed travelers on the new four-lane section of US Highways 11, 80, and 45 in Meridian. Truck repairs and fuel sales continued until around 1990, when it became a restaurant only. The business closed in 1999 and was demolished in 2000. The iconic sign was preserved and remains in place.

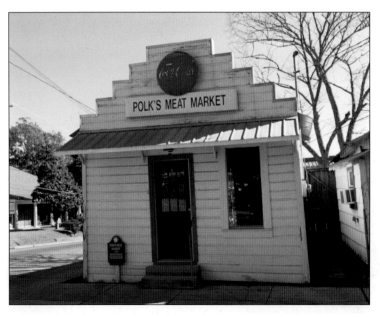

POLK'S MEAT MARKET, WOODVILLE, 2018. Polk's Meat Market in Wilkinson County is an early example of an African American business open on a town square during the segregation era. Located in a small two-room building built around 1900, Jim Johnson's Meat Market was passed on to his son Lawrence Polk in 1954. Johnson owned a 700-acre plantation named Sugar Hill.

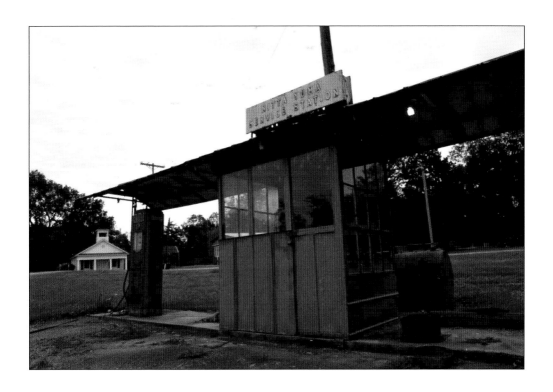

NITTA YUMA SERVICE STATION, NITTA YUMA, 2021. The Nitta Yuma Service Station is in the historic plantation town of Nitta Yuma. The property has been in the same family for over 200 years. Located on Highway 61 in Sharkey County, Nitta Yuma is what remains of a larger plantation derived from Choctaw land. Maj. Burwell Vick and his brother Rev. Newit Hartwell Vick migrated from Virginia to Mississippi in the early 1800s. Settled by Major Vick, the farm remained a Vick plantation for several generations. Henry and Sara Vick's daughter Mary Bullock Vick married Alonzo Jefferson Phelps in 1865, moving to Nitta Yuma in 1877. Through her marriage, it became Phelps property, which continues today. Vicksburg was named in honor of Newit Hartwell Vick in 1825. The name *Nitta Yuma* comes from Choctaw, meaning bear tracks or "mixed with bear."

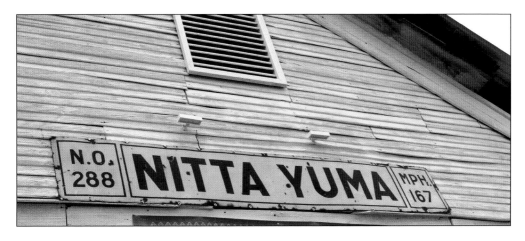

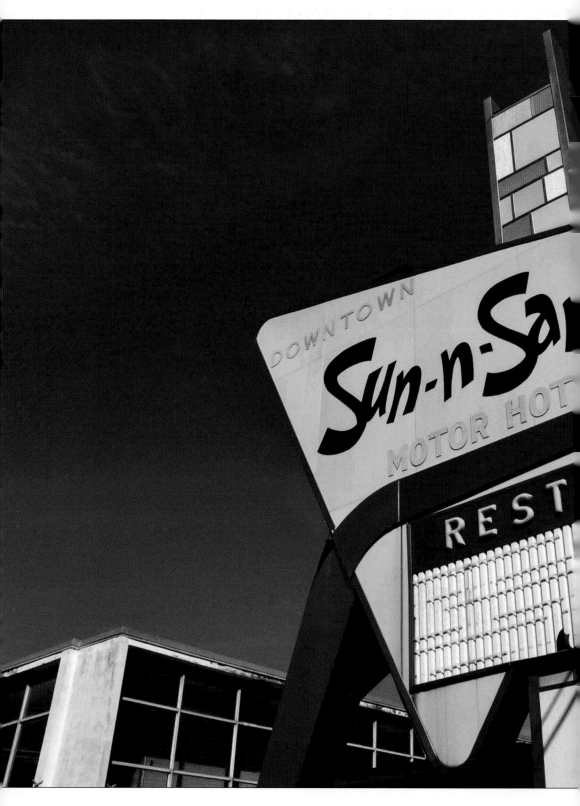

SUN-N-SAND MOTOR HOTEL, JACKSON, 2021. The Sun-N-Sand Motor Hotel, with its iconic modernist sign, was a reflection of historic changes in Mississippi in the 1960s. Opened by Dumas Milner near the state capitol in 1960, the motel was a temporary home for state legislators and a gathering place for civil rights activists. Wednesdays in Mississippi, a multi-racial, women-led initiative designed to build relationships between northern and southern women on racial justice, was held here. John Grisham wrote his first novel, *A Time to Kill,* here in the mid-1980s while in the Mississippi House of Representatives. The motel is featured in *My Cat Spit Magee* by Willie Morris and *The Help* by Kathryn Stockett. After 40 years in business, it closed in 2001. Despite attempts to save the structure, the motel was demolished in 2021; however, the State of Mississippi plans to preserve the sign and ballroom.

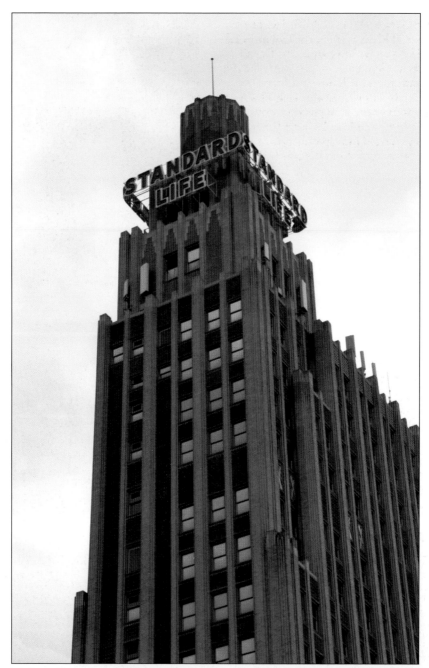

Standard Life Building, Jackson, 2022. The Standard Life Building has been a Jackson landmark since 1929. Constructed as the Tower Building, the 22-story Art Deco structure was designed by Jackson architect Claude H. Lindsley. At the time, the Tower Building was one of Jackson's tallest buildings, and among the tallest all–reinforced concrete structures in the United States. The building suffered from being opened at the start of the Great Depression and went into foreclosure. The Standard Life Insurance Company relocated here from the Plaza Building in 1951 and installed the neon sign. In 2020, the building was renovated into upscale apartments as Standard Life Flats, a part of the King Edward Hotel preservation project.

UNION HOTEL, MERIDIAN, 2019. Two blocks from the old Union Station, the Union Hotel provided lodging within easy access for rail passengers in Meridian. The four-story building dating from around 1910 was first owned by P.C. Steele. Rooms were available at $2 a night for frequent travelers. The property was sold by the Williams family in 1981, and the hotel was later converted into apartments. This sign on Front Street dates from the late 1930s.

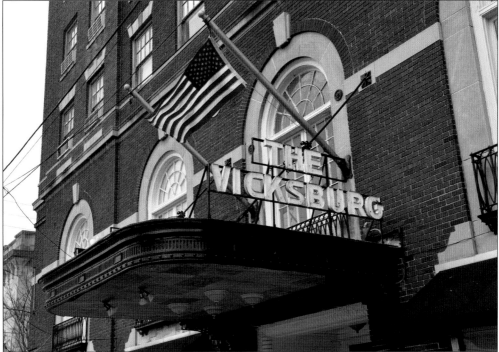

HOTEL VICKSBURG, VICKSBURG, 2022. The Hotel Vicksburg is the tallest building in Vicksburg, built around 1928 through local investment capital. Stock was sold by realtor John Hoggatt, cotton dealer K.D. Wells, banker E.S. Butt, and merchant Edgar Leyens to form the Magnolia Hotel Company. At the time, the recently completed Yazoo River bridge and soon-to-be-completed Mississippi River bridge would make Vicksburg an important crossing point on US Route 80.

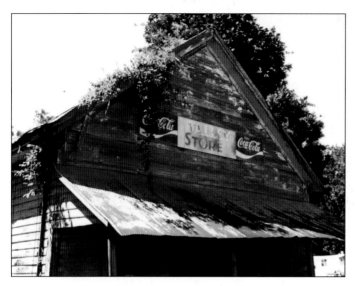

VALLEY STORE, VALLEY, 2017. The Valley Store was established in Carroll County by J.J. Hambrick in the 1880s. The general store had a succession of owners in the early 1900s. It was also known as Moreland's Store, owned by Hilman Moreland until 1968. The store closed in 1994. Mississippi John Hurt played guitar on the porch at the Valley Store and Stinson's Store in nearby Avalon. Hurt was a major figure in the folk blues revival of the 1960s.

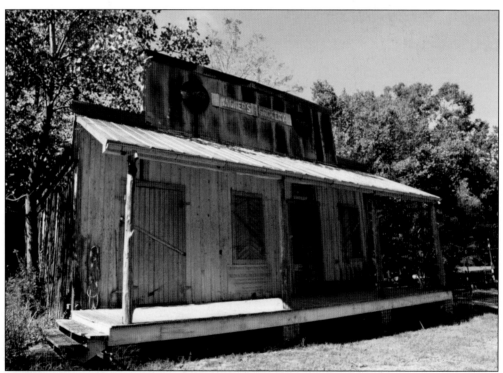

WAGNER'S STORE, CHURCH HILL, 2021. Wagner's Store is one of the oldest country stores still standing in Mississippi. Located in Jefferson County, the store was built around 1875 for French immigrants Isaac Marx and Emile Moser. It is the oldest known all-wooden heart pine country store with a post office in the southeastern United States. Adolph Wagner bought the store in 1927 and his family operated the Church Hill Post Office until 1992. The store closed in 1998 and was donated to the Church Hill Historic Society for preservation.

Two

BUSINESS AND STOREFRONT SIGNS OF MISSISSIPPI

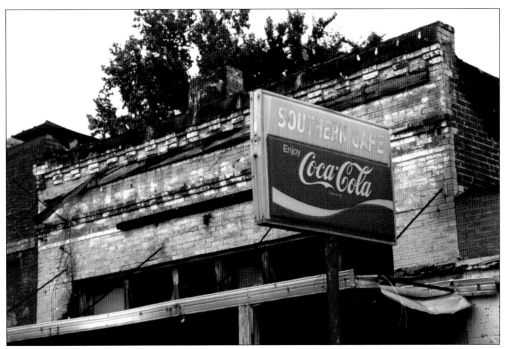

SOUTHERN CAFE, ITTA BENA, 2019. A quintessential small-town diner, the Southern Cafe was witness to most major events of the 20th century. Opened in 1911 by Italian immigrant John Favara, the café was originally a grocery and restaurant. The business survived through two World Wars, the Great Mississippi Flood of 1927, the Great Migration, and the peak of the railroads. Named for the Southern Railroad, the old train depot was directly in front of the café.

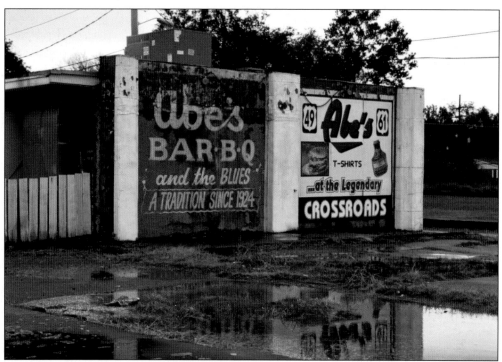

ABE'S BAR-B-Q, CLARKSDALE, 2019. Abe's Bar-B-Q in Clarksdale is the oldest barbeque in Mississippi. Opened in 1924 as the Bungalow-Inn by Abraham Davis on Fourth Street, now Martin Luther King Blvd., the business relocated to the famous crossroads at Desoto Avenue and North State Street in Clarksdale. It was renamed Abe's to honor Davis in 1960. Abe's is famous for its original barbeque "Comeback Sauce" and oil-and-vinegar coleslaw.

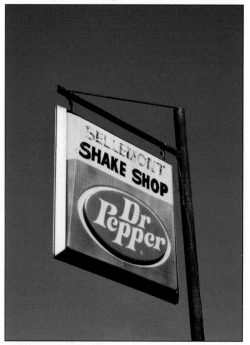

BELLEMONT SHAKE SHOP, NATCHEZ, 2018. The Bellemont Shake Shop was opened in the mid-1960s on Highway 61 in Natchez. The sign advertises Dr Pepper, the oldest major soft drink in America, invented in 1885 by pharmacist Charles Alderton at Morrison's Old Corner Drug Store in Waco, Texas. Dr Pepper was originally called a "Waco." Store owner Wade Morrison is credited with naming Dr Pepper, although the origin of the name is unclear. In the 1950s, the logo was redesigned with the text slanted and the period dropped.

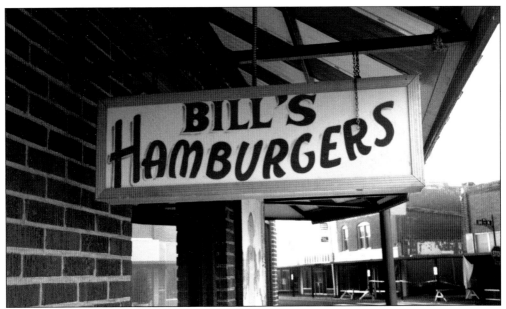

BILL'S HAMBURGERS, AMORY, 2019. Bill's Hamburgers is one of the oldest continuously operating hamburger stands in the country. Opened in 1929 by Bob Hill, the original store was named Bob's Hamburgers and housed at a different Amory location. Hill shut the business down during World War II because of meat rationing. Bob's was renamed Bill's after an ownership change. The burgers are ground fresh daily and ordered with onions and mustard ("with") or plain ("without").

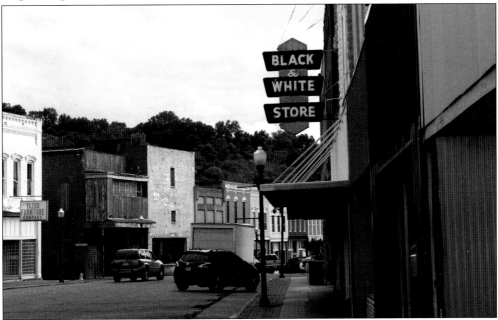

BLACK & WHITE DEPARTMENT STORE, YAZOO CITY, 2017. The Black & White Store was a Yazoo City landmark where customers could buy clothing, shoes, fabrics, and hard-to-find items with personal service. The store was opened in 1939 by Louis Price on Main Street. Jimmy Chisolm was hired as a salesman in 1961 by owner Bernard Fink. Chisolm became manager and owner, operating the business until it closed in 2017.

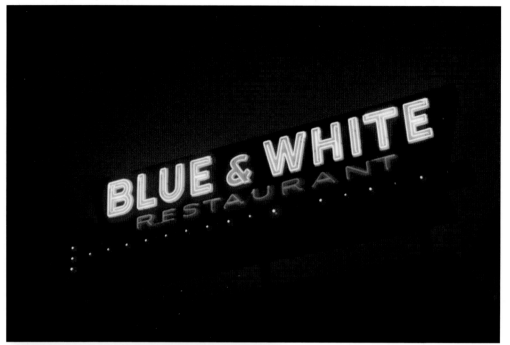

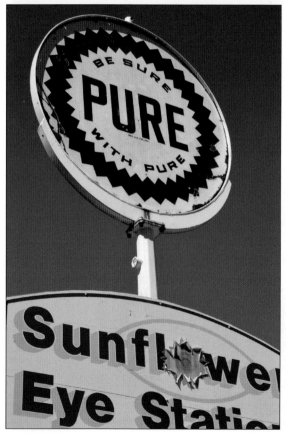

BLUE & WHITE RESTAURANT, TUNICA, 2016. For nearly a century, the Blue & White has been serving plate specials on Highway 61 in Tunica. Established in 1924 on old Route 61 along the railroad in downtown Tunica, the Pure Oil company moved the Blue & White Service Station and Cafe in 1937 to its present location shortly after the construction of the new Highway 61.

PURE OIL SIGN, RULEVILLE, 2019. The origin of Pure Oil dates to 1914 with the founding of Ohio Cities Gas Company. In 1920, Ohio Cities changed its name to Pure Oil. Pure Oil stations were constructed using traditional blue and white colors. Union Oil Company of California purchased Pure Oil in 1965. By 1970, the brand was phased out and rebranded as Union 76. The Pure Oil name returned in 1993 as a cooperative to supply members in 10 southern states.

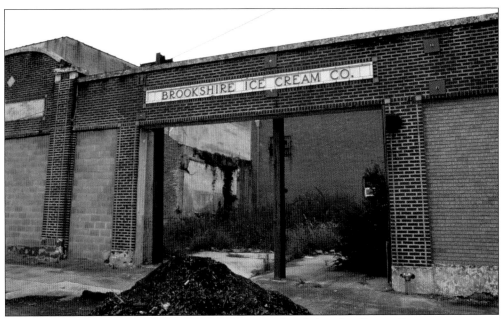

BROOKSHIRE ICE CREAM COMPANY, MERIDIAN, 2019. Brookshire Ice Cream Co. was a pioneer in ice-cream manufacturing in east central Mississippi. Established by N.D. Brookshire in 1912, the company supplied drugstores, restaurants, and schools. Advertised as "A Real Health Food" in the 1920s, the company was located in a one-story industrial building erected around 1924. Eula Brookshire became manager after her husband's death in 1934, and son N.D. "Dee" Brookshire Jr. became president after World War II.

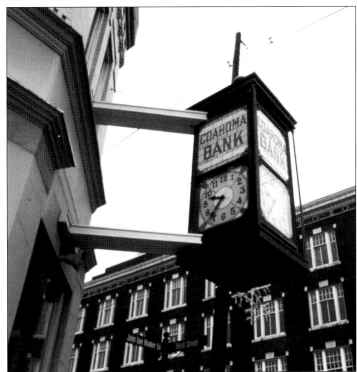

COAHOMA BANK, CLARKSDALE, 2019. When many Delta banks were closed during the Great Depression, the Coahoma County Bank and Trust Company opened in 1931. Through many mergers, name changes include Planters Bank, Planters National Bank and Trust Company, Coahoma County Bank and Trust Company, and Coahoma National Bank. The location is currently a branch of CB&S Bank. The 1930s-era clock was restored and reinstalled in 2006. The Coahoma Bank Building was constructed in 1904.

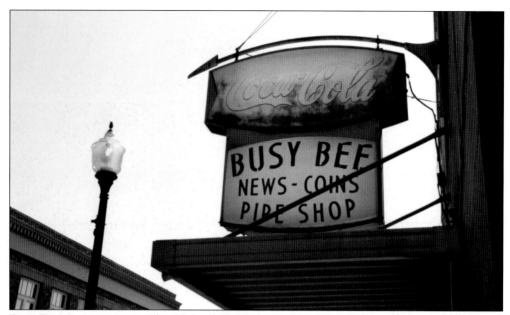

BUSY BEE, LAUREL, 2021. This "fishtail" logo was used by Coca-Cola on signs and all forms of advertising from 1958 to 1965. The arciform shape was phased out in favor of the iconic red disc that had been used in earlier Coca-Cola advertising. The fishtail design, influenced by automobile tailfins of the late 1950s, is popular among collectors for being period specific.

COCA-COLA PORCELAIN SIGN, GREENWOOD, 2017. Durable and weather resistant, porcelain was an important material for outdoor advertising signage from the 1880s to the 1950s. Imported from Germany to the United States in the 1890s, porcelain signs featured layers of powdered glass fused by color onto a base of heavy rolled iron and die cut into shapes. This porcelain Coca-Cola sign, which dates from around 1939, is on Carrollton Avenue in Greenwood.

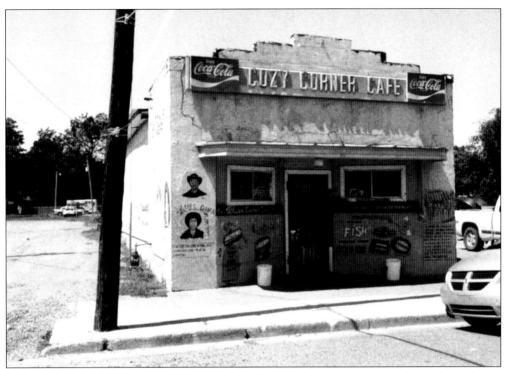

COZY CORNER CAFE, INDIANOLA, 2016; AND MOORHEAD REC CENTER, MOORHEAD, 2017.
Disappearing from the American landscape are the once-popular "privilege" signs. This is an industry term for promotional signs installed on storefronts by corporations, most famously by Coca-Cola, at no cost to the owner. Prominent from the 1930s to the 1960s, privilege signs offered instant brand recognition to local grocery and convenience stores. Coca-Cola privilege signs were offered to retailers by company representatives or local bottling companies in a variety of styles that could be customized by the store owners. Coca-Cola "goldline" signs are named for the rails that individual letters were placed on.

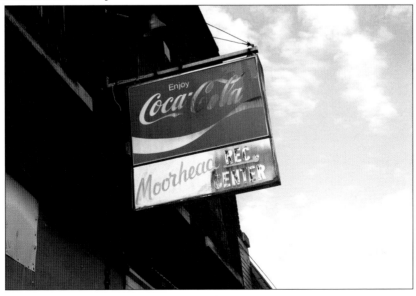

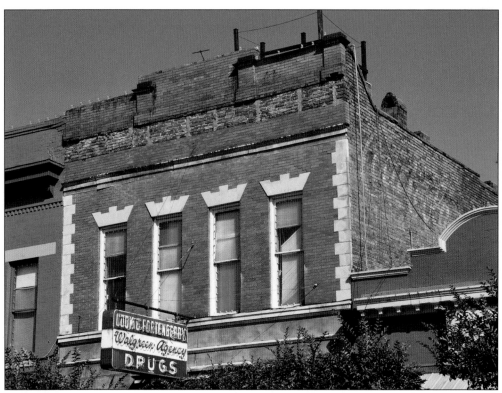

Cook & Fortenberry Pharmacy, Columbia, 2021. William Fortenberry founded Cook & Fortenberry pharmacy in 1954 in the former location of Pearl River Bank, established around 1904 by Benjamin Alexander Williamson. In 1992, pharmacist John Hoffman bought the store. Kayla and Eric Thomas took over the business in 2017. The original Walgreen Agency sign, made by Acme-Wiley Co. of Chicago, survived Hurricane Katrina in 2005.

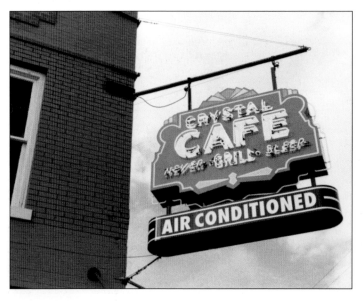

Crystal Grill, Greenwood, 2016. The Crystal Grill is among Mississippi's oldest restaurants. Opened as the Elite Cafe by the Carnaggio brothers in the 1920s, it became the Crystal Cafe in 1935 with the arrival of Greek immigrant Jim Liollio. In 1952, the business was bought by the Liollio family and Mike Ballas. In 1977, Mike Ballas bought the family business. His son John Ballas is the current owner.

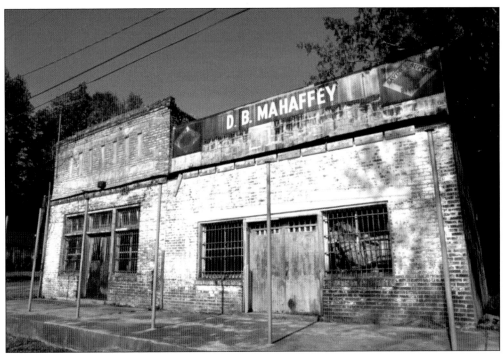

D.B. Mahaffey Mercantile Store, Braxton, 2021. D.B. "Boots" Mahaffey was a Braxton native and owned Mahaffey Mercantile Store. He was mayor of Braxton for 24 years, justice of the peace for eight years, and president of Bankers Trust Savings and Loan Association. Braxton, in Simpson County, was a stop on the Gulf & Ship Island Railroad in the early 1900s. Local sawmills shipped lumber from Braxton Station.

Delta Feed Company, Greenwood, 2019. The Delta Feed Company was a longtime Greenwood fixture selling garden and agricultural goods. The store was established in 1898 by the Simmons family as the Delta Feed and Seed Company. In 2020, the business closed after water damage collapsed a portion of the roof and wall of the historic c. 1918 building.

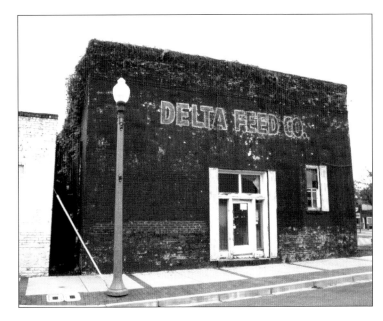

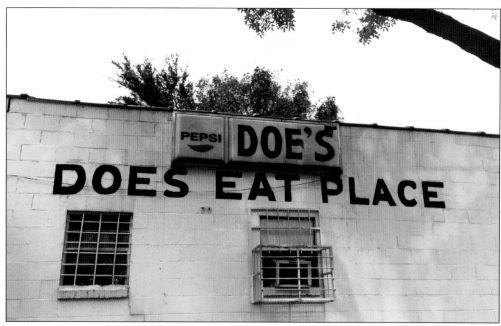

Doe's Eat Place, Greenville, 2019. Famous for steaks and hot tamales, Doe's Eat Place has been a Greenville landmark for over 80 years. Founded in 1941 by Dominick Emile "Doe" Signa and his wife, Mamie, Doe's is currently operated by the Signa family. Doe's father opened a grocery store in 1903 in the current original building, which once operated as a honky-tonk. Mamie started making tamales in 1941.

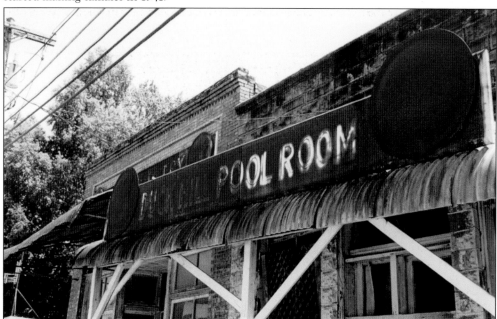

Duck Hill Pool Room, Duck Hill, 2019. Duck Hill is named for a large hill northeast of town where Chief Duck, a medicine man and shaman, lived and held war councils. The town name is probably translated into English from the Choctaw language. The land for Duck Hill was secured from the Choctaw around 1820, and the town was established around 1825.

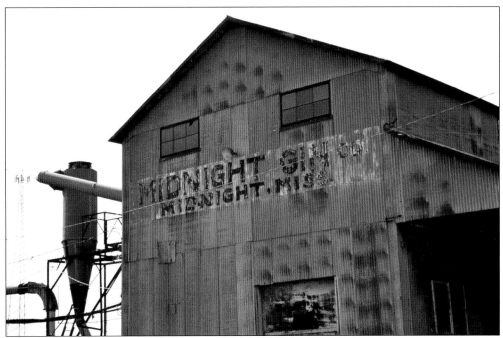

MIDNIGHT GIN COMPANY, MIDNIGHT, 2021. Mississippi ranks among the top cotton-producing states, although soybeans and corn have replaced cotton as top crops. Many cotton gins have disappeared over the last 50 years. In 1971, there were 482 active cotton gins, dropping to 292 a decade later. In 2009, there were 72, and in 2021, Mississippi had 38 active gins. The Midnight Gin Company, one of the few remaining in operation, was founded in 1965 in Humphreys County.

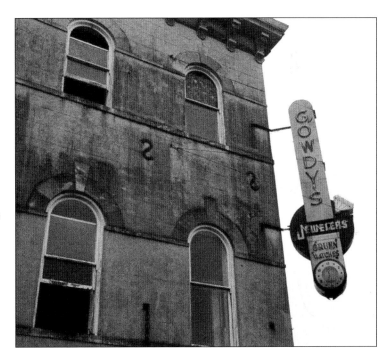

GOWDY'S JEWELERS, CANTON, 2021. The Gowdy's Jewelers sign has been a longtime fixture on the square in downtown Canton. Founded by Ted W. Gowdy in 1948, he operated the business with his wife, Mildred, until his death in 1974. His son Ted A. Gowdy ran the business until his retirement in 2000. The Gowdy Building, erected around 1855, was a former Masonic lodge.

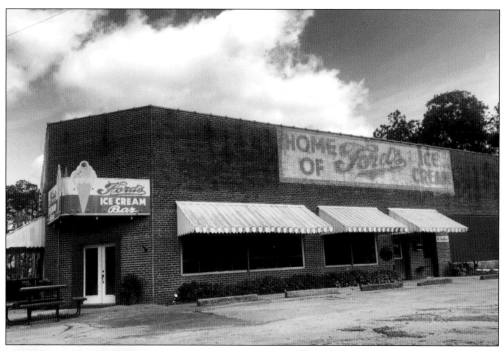

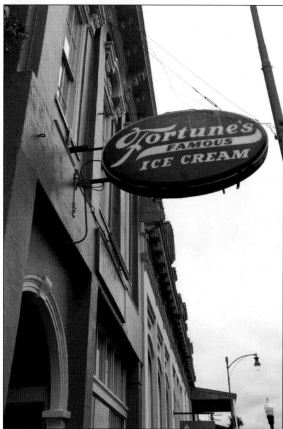

FORD'S ICE CREAM, NEWTON, 2022. Ford's Ice Cream was established by J.F. Ford in 1913. He formulated an ice cream mix and began selling it on North Main Street in Newton. J.F. Ford Jr., a World War II veteran, built Ford's Ice Cream plant in 1946 on West Church Street. In 1967, the plant was sold to W.A. McClendon and T.L. Thompson, who expanded sales across the state.

FORTUNE'S ICE CREAM SIGN, OXFORD, 2019. Fortune's started as a pharmacy in Memphis in the 1920s that expanded to selling ice cream. In the 1960s, it operated entirely as an ice cream distributor in the area. This sign is at the former Blaylock Drug Store at Courthouse Square, now Square Books. Blaylock Drug Store, founded by Nolan Blaylock in 1945, was an Oxford landmark for 41 years. Square Books opened in 1986 after the renovation of the c. 1880 building.

GUS CAFE, HATTIESBURG, 2019. For over 70 years, Gus Cafe served home-cooked meals in Hattiesburg. Founded in 1927 by Greek immigrant Gust Vistinos, the original Gus Cafe No. 1 was at Batson and Market Streets. Gus Cafe No. 2, where this sign is located, was opened in 1951 by Gus and daughter Angela Vistinos Georgian at Front and Market Streets. Angela operated the restaurant until her death in 2003. The business closed after damage from Hurricane Katrina in 2005.

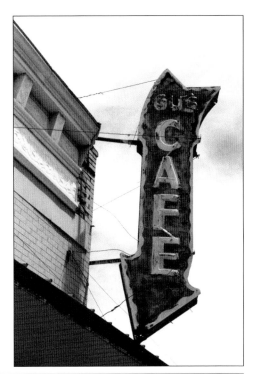

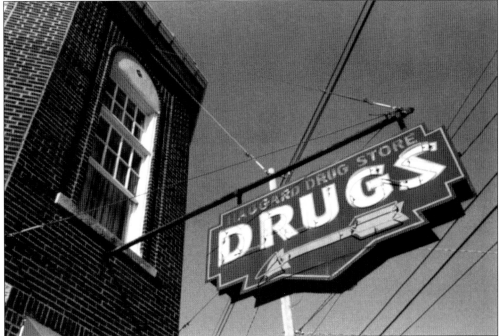

HAGGARD DRUG STORE, CLARKSDALE, 2016. Haggard Drug Store was a part of the Clarksdale business community for 80 years. Edwin P. Haggard arrived in Clarksdale from Alabama in 1927 to become a member of the Stovall Drug Store company. In 1929, the firm became Stovall-Haggard Drug Store. In the 1930s, it became Haggard Drug Store, located in the old Masonic Temple building erected around 1923. The store remained in business until around 2010.

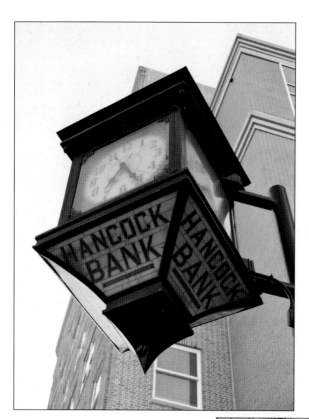

HANCOCK BANK, GULFPORT, 2019. The Hancock Bank has roots on the Mississippi Gulf Coast in the 19th century. The Hancock County Bank was organized in Bay St. Louis in 1899 and moved to this Gulfport location in 1933. It shortened its name to Hancock Bank in 1938. The clock was refurbished and reinstalled in 1989 after damage from Hurricane Elena in 1985. The current name is Hancock Whitney Bank.

INDIANOLA BANK, INDIANOLA, 2016. The Indianola Bank was established in 1940, a branch of the Ruleville-based Planters Bank & Trust Company. The Indianola Bank assumed the Planters Bank & Trust name at this location on Front Avenue in 1980. Planters Bank was founded in 1920 and was one of the few Delta area banks that survived the Great Depression.

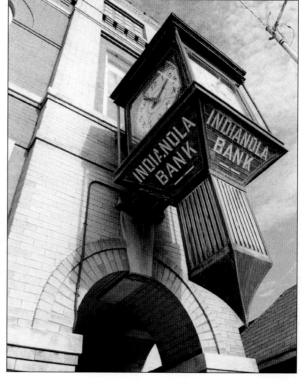

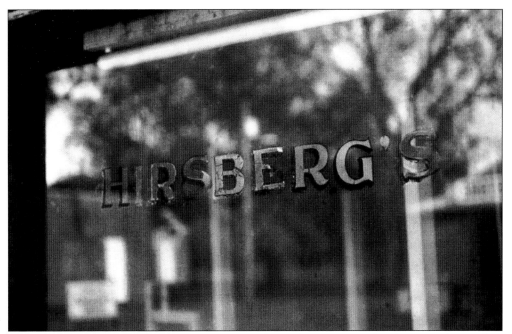

HIRSBERG'S DRUGSTORE, FRIARS POINT, 2019. Hirsberg's Drugstore was the place to go for supplies, clothing, sundries, and ice cream in Friars Point. The three-generation business, founded by Jacob Hirsberg in the early 1900s, was passed on to son Sol Hirsberg in 1935, then to grandson Robert Hirsberg. Coca-Cola was made on the premises with syrup, ice, and carbonated water. Blues legends Robert Johnson and Robert Nighthawk played for crowds in front of the store.

JIM'S CAFE, GREENVILLE, 2019. Jim's Cafe has been serving home-cooked meals in Greenville for over a century. Established in 1909, the diner is the oldest in Washington County. George Demitros and Andrew Johnson bought the restaurant in 1927. Through the decades, the café remained a family-owned Johnson business. Longtime owner Gus Johnson, famous for his salad dressing and hot sauce, passed away in 2017.

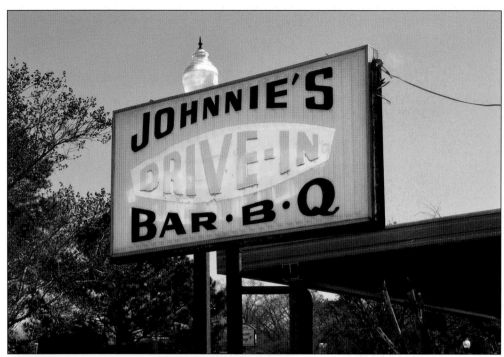

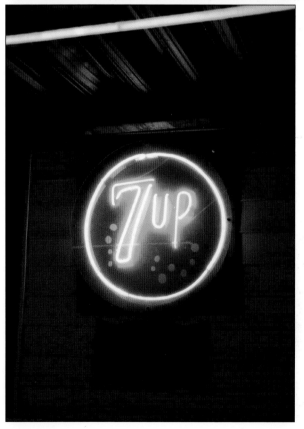

JOHNNIE'S DRIVE-IN, TUPELO, 2022. Opened in 1945 by Johnnie and Margaret Chism, Johnnie's is Tupelo's oldest operating restaurant. Complete with Elvis booth and memorabilia, legend has it that Elvis Presley ate here as a youngster before moving to Memphis. The original decor drive-in is famous for Depression-era doughburgers, a secret recipe mix of hamburger and flour. In 2020, Christi White took over the restaurant from her father, Don Knight. A vintage neon 7-Up sign greets customers at the drive-in's entrance. 7-Up was created by Charles Leiper Grigg, who started the Howdy Corporation in St. Louis in 1920. He created the formula for Bib-Label Lithiated Lemon-Lime soda in 1929. The name was later changed to 7-Up Lithiated Lemon Lime and just 7-Up in 1936.

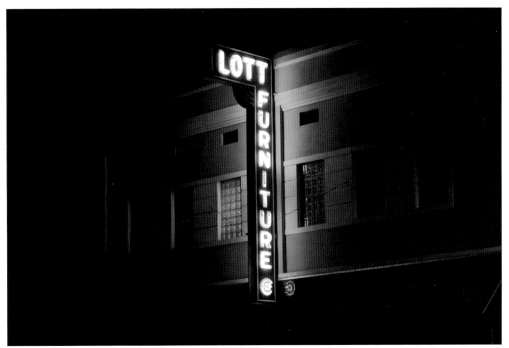

LOTT FURNITURE, JACKSON, 2022; AND LAUREL FURNITURE, LAUREL, 2021. Lott Furniture was first opened by Reuben Lott in Laurel in 1917. Lott opened this location on West Capitol Street in Jackson in 1935. The store was managed by J.B. Chapman. In 1959, the store was managed by James P. Smith, the previous manager at the Lott store in Laurel. Smith eventually bought the store, which remained open into the 2010s. By 1965, there were 11 Lott Furniture stores in Mississippi. Laurel Furniture, the second location in Laurel, was opened in the late 1960s. Managed by Willie Joe Rowell, it carried more upscale finer furniture and catered to different kinds of customers. Lott sold Laurel Furniture in the 1980s. Southern Antiques now occupies the building on Central Avenue.

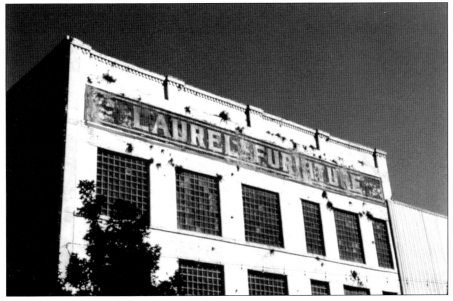

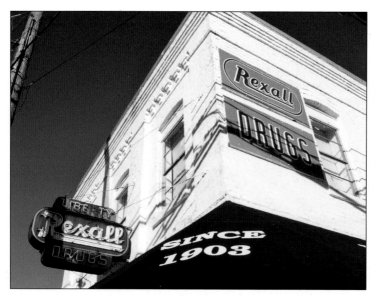

LIBERTY DRUG STORE, LIBERTY, 2018. Since 1903, Liberty Drug Store has been a social institution at the corner of Main and North Church Streets in Amite County. In 2000, Ronnie Blalock bought the store from Winbourne Sullivan, the previous owner of 35 years. The store has stood the test of time, including a fire in 1996. The indoor layout has remained largely unchanged since the 1960s.

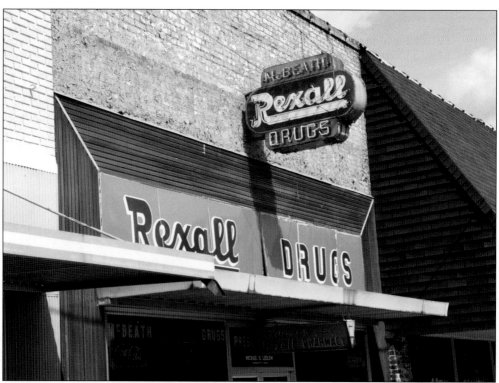

MCBEATH DRUG STORE, NEWTON, 2022. In 1922, pharmacist J.C. McBeath arrived in Newton to establish McBeath Drug Store in the G. Miller Gallaspy building, built around 1907 on North Main Street. Ellis Chance and George Nicholson took over when McBeath passed away in 1963. In 1992, pharmacist Michael Ledlow bought the store from Ellis and Paul Chance. The business closed, but the classic mid-20th century blue and orange Rexall signage remains.

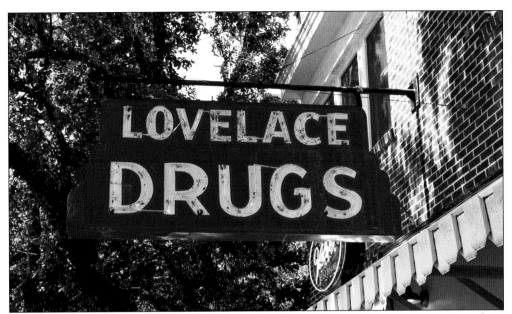

LOVELACE DRUGS, OCEAN SPRINGS, 2019. Lovelace Drugs was an institution in downtown Ocean Springs. Dr. Oscar Lee Bailey constructed the building in 1926 at Washington Avenue and Government Street, moving his drugstore from a nearby location. In 1948, Roland Lovelace bought the building from the Bailey family and opened Lovelace Drugs. The iconic sign was saved by the Ocean Springs Historic Preservation Ordinance. The business closed in 2020.

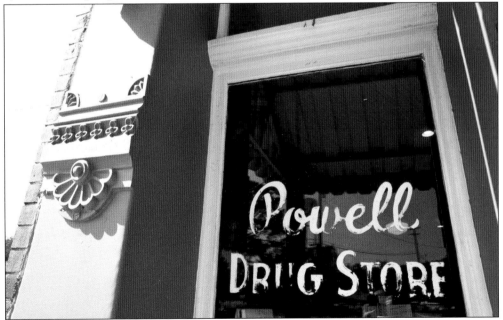

POWELL DRUG STORE, MOUNT OLIVE, 2021. Powell Drug Store is one of the oldest family-owned pharmacies in Mississippi. D. Graham Calhoun, the first druggist in Mount Olive, erected the Calhoun Drug Company building in 1904. In 1956, Ernest McRaney bought the pharmacy and operated it as City Drug Store. The building was purchased by Homer Powell in 1961 and has been Powell Drugs since then. In 2004, Homer Powell passed the business to his son, Bill Powell.

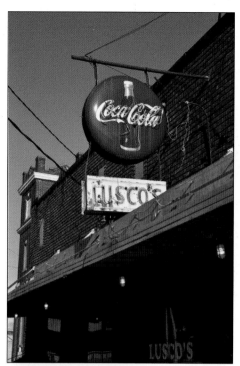

LUSCO'S RESTAURANT, GREENWOOD, 2019.
Lusco's was started in 1921 as a grocery by
Sicilian immigrants Charles and Marie
Lusco. A fire destroyed the original location
in 1929. Lusco's opened on Carrollton
Avenue in 1933 during the last year of
Prohibition, with a grocery in front and
privately partitioned booths in the rear. The
four-generation restaurant closed in 2021. In
1965, Booker Wright, an African American
waiter at Lusco's, sparked controversy when
he spoke openly in an NBC documentary
on racism and the changing South.

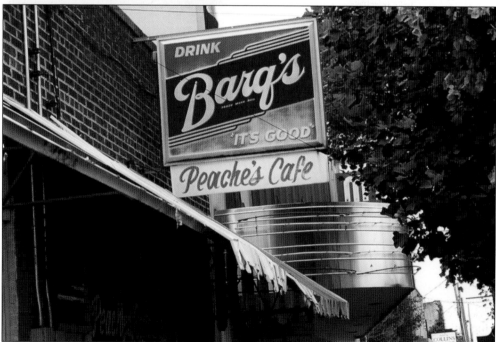

PEACHES CAFE, JACKSON, 2017. Peaches Cafe was a center for the cultural life of African Americans
on Farish Street. Founded by Willora "Peaches" Craft Ephram in 1961, the café served soul food
and was a gathering place for voting rights activists in the 1960s. Notable customers included
Muhammad Ali, B.B. King, Medgar Evers, and Barack Obama. With the decline of Farish Street,
the café closed in 2015. Miss Peaches passed away in 2018.

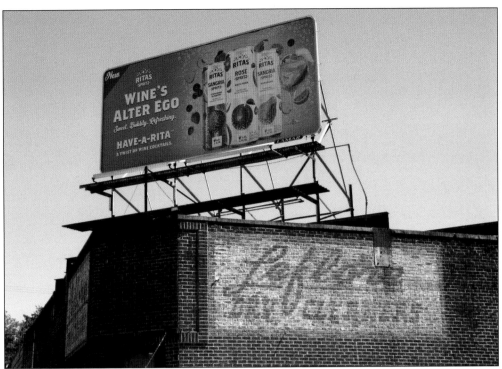

LEFLORE DRY CLEANERS, GREENWOOD, 2019. Leflore Dry Cleaners was a cornerstone Greenwood business located at Main and Market Streets. The business was opened in 1948 by Greenwood mayor Charlie Sampson. Ray Jackson joined the cleaners in 1957 and bought the business in 1971. It is now home to Howard and Marsh Exchange, a boutique vendor market named to honor Titus Howard and Samuel Marsh, landowners who sold most of the property downtown Greenwood is constructed on.

1 HOUR MARTINIZING, TUPELO, 2019. Neon signs reached peak popularity from the 1920s to the 1960s. Neon was first demonstrated by French engineer Georges Claude in 1910. In 1923, Claude introduced neon gas signs in the United States. It quickly became a popular form of outdoor advertising. Since the 1970s, neon has been in decline in favor of incandescent and LED signs. However, neon remains valuable to invoke the nostalgia of the 1940s and 1950s.

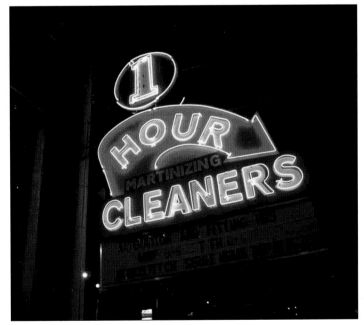

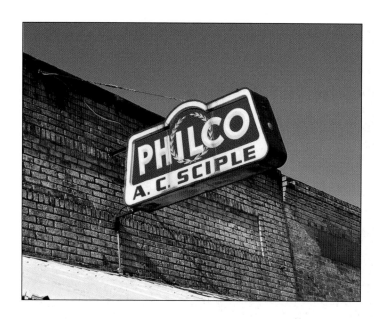

PHILCO SIGN, SHUQUALAK, 2018. This Philco sign from around 1960 advertises A.C. Sciple Appliance Company in the Noxubee County town of Shuqualak (pronounced "sugar lock.") Before A.C. Sciple, this was the site for L.T. Anderson General Store and a movie theater in the 1940s. In the mid-1960s, it became Ledbetter's Furniture and Appliance, operated by Jack Ledbetter for 40 years. Philco was a pioneer in home appliances, radios, and televisions.

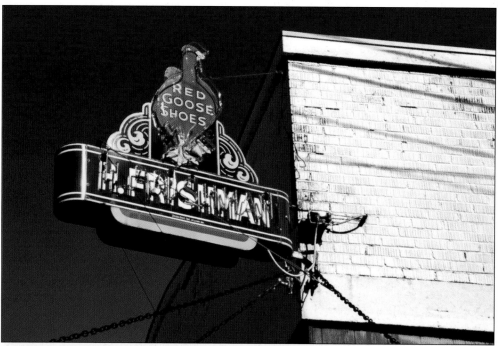

RED GOOSE SHOES SIGN, PORT GIBSON, 2018. This Red Goose Shoes design incorporates H. Frishman Dry Goods in a sign from the late 1930s. H. Frishman Dry Goods was owned by Herman and Miriam Frishman Marx, and later by son Henry, in the early to the mid-20th century. The Red Goose Shoes brand was trademarked in 1906. It was actively promoted with lighted signs until the popular red mascot was discontinued in the 1970s. This sign was manufactured by Zeiser Brothers Sign Co. of St. Louis.

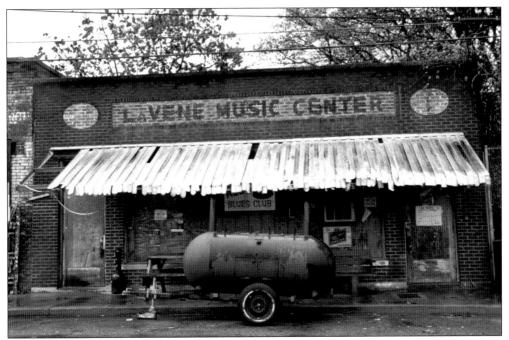

RED'S BLUES CLUB, CLARKSDALE, 2019. Red's Blues Club is a traditional blues juke joint in Clarksdale. The club was opened in the 1980s by Red Paden in the former LaVene Music Center on Sunflower Avenue. Joseph P. LaVene, one of Coahoma County's last World War I veterans, owned and operated the music center for 40 years until his retirement in 1982. Ike Turner and his Rhythm Kings bought instruments at LaVene's around 1950.

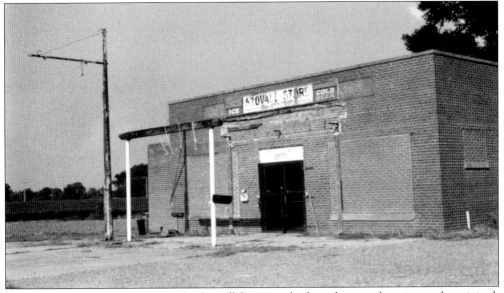

STOVALL STORE, STOVALL, 2016. The Stovall Store was built in the same location as the original, wood-framed Stovall Plantation commissary, located here in the early 20th century. After the commissary burned, the Stovall Store was later built and became a fishing tackle shop. William Howard Stovall II owned Stovall Plantation when blues legend Muddy Waters lived in a sharecropper cabin.

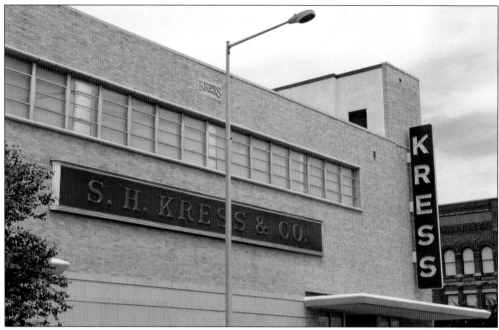

S.H. Kress & Company, Meridian, 2019. Combining Art Deco with "five and dime" commerce, the Kress building was constructed in 1934 by Kress architect Edward F. Sibbert. An addition was completed in 1957. Founded in 1896, there were 221 Kress stores in 28 states at the chain's peak. The Meridian Kress building was remodeled in 2015 as part of Mississippi State University's Meridian Campus, now the I.A. Rosenbaum Building.

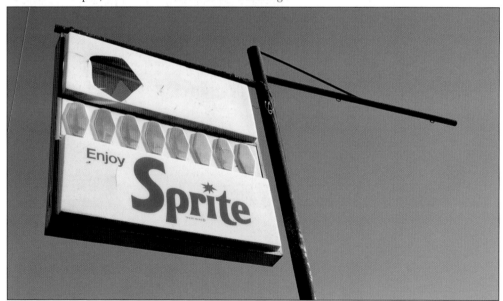

Sprite Sign, Fayette, 2018. Sprite was introduced by the Coca-Cola Company as a competitor to 7-Up in 1961. The clear, lemon-lime drink began in West Germany in 1959 as Fanta Klare Citrone (Clear Lemon Fanta). Since its introduction, the color green has been associated with the brand's packaging and marketing. The name originated from the Coca-Cola "sprite boy" character. The design on this sign represented Sprite from 1974 to 1984.

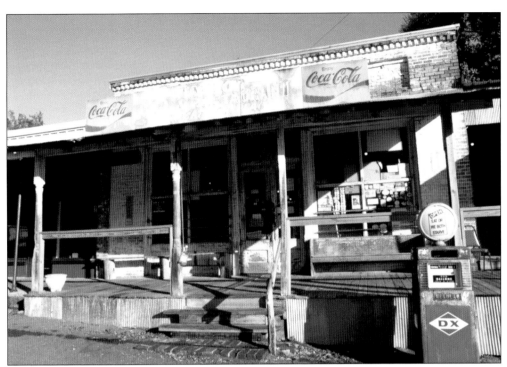

TAYLOR GROCERY, TAYLOR, 2018.
The Taylor Grocery is famous for serving catfish in the rural Lafayette County town of Taylor. Built around 1889 by Duff Ragland, it has served as a dry goods store and country grocery. Jerry and Evie Wilson began serving catfish in Taylor in 1977. Lynn Hewitt bought the store in 1997 when it was a general store that sold catfish on the weekends.

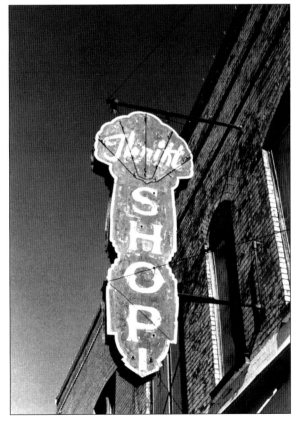

THRIFT SHOP SIGN, BELZONI, 2016. This thrift shop sign remains suspended in time on West Jackson Street in Belzoni. The sign dates from the mid-to-late 1930s and was originally used for the Belzoni Cafe. Famous for catfish production, Belzoni is known as the "Catfish Capital of the World." Marion Post Wolcott photographed Belzoni and the Mississippi Delta in 1939 and 1940 for the Farm Security Administration.

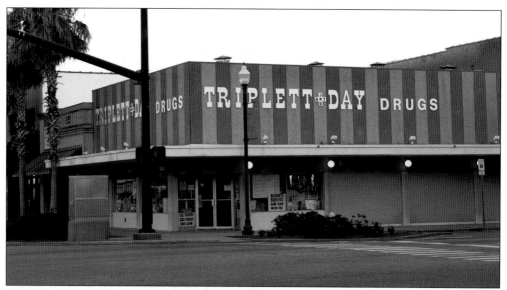

TRIPPLETT-DAY DRUG COMPANY, GULFPORT, 2022. For 65 years, Tripplett-Day Drug Co. was a local gathering place for Gulf Coast residents. Opened in 1955 by Jim Day and William Tripplett, the store was at the corner of Highway 49 and Fourteenth Street. Remodeled and expanded in 1961, the store retained its old-time ambiance with a soda fountain and lunch counter. Day, the original pharmacist, was there when the business closed in 2020.

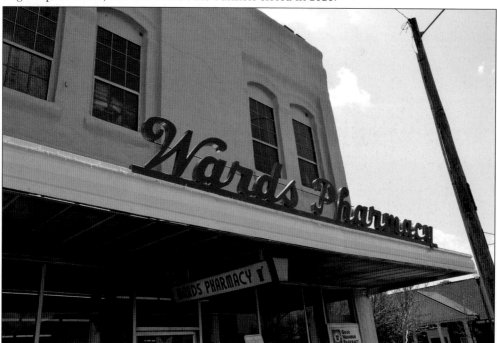

WARD'S PHARMACY, ELLISVILLE, 2022. Since 1886, Ward's Pharmacy has been in its original Ellisville location on South Front Street. The drugstore was founded by E.J. Ward and B.D. Red. Basil Red Jr. took over the business after World War II, followed by his daughter Nikki Red-Walters in 2000. In 2017, manuscripts written by the late Basil Red Jr. detailing his experiences as a World War II airman were turned into the book *Crew No. 3484*.

KELLOGG'S HARDWARE AND APPLIANCE, WEST POINT, 2018. Kellogg's Hardware was a fixture in West Point for 70 years. Opened by L.C. "Buck" Kellogg Sr. after World War II in 1946, the store moved to a larger, modernized location on Commerce Street in 1952. The original sign was repaired in 1965 and again in the 1980s. His son Bucky, with the business since 1971, closed the store on his retirement in 2021.

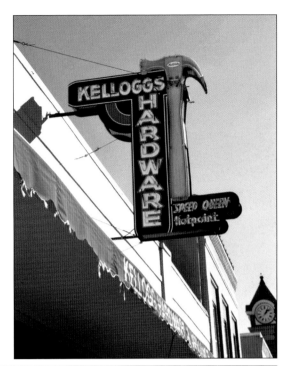

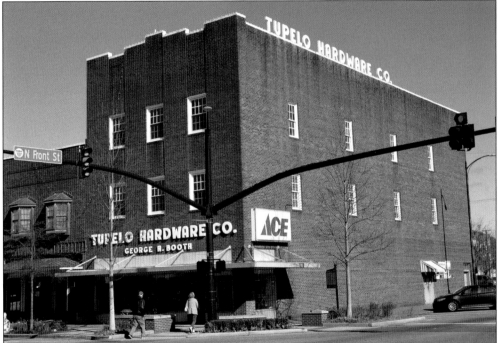

TUPELO HARDWARE, TUPELO, 2022. Tupelo Hardware Company is a family business owned and operated by four generations of the Booth family. Founded in 1926 by George H. Booth across the street from the current location, the store is famous for selling Elvis Presley his first guitar in 1946, with his mother Gladys. William "Bill" Booth operated the store from 1945 to 2000. The store has been in this three-story brick building on West Main Street since 1942.

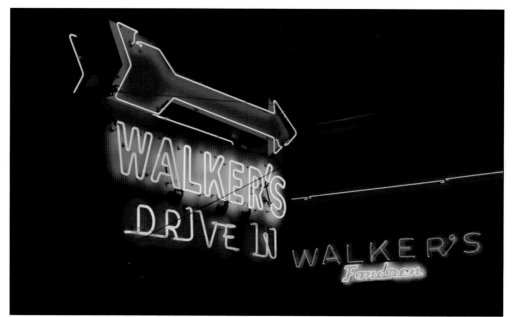

WALKER'S DRIVE-IN, JACKSON, 2022. Walker's Drive-In was opened in 1948 by Geneva and E.B. Walker in the Fondren district of Jackson. The drive-in served breakfast, lunch, and dinner, complete with car hops, an indoor counter, tables, and booths. Retaining the original black-and-white tiles and décor, Walker's is now an upscale restaurant with southern classics reimagined by Derek Emerson, the executive chef and owner.

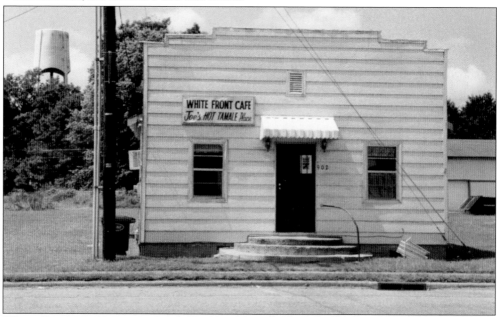

WHITE FRONT CAFE, ROSEDALE, 2016. The White Front Cafe, also known as Joe's Hot Tamale Place, was founded by Joe Polk, serving takeout tamales in the 1970s. Polk is believed to have obtained a tamale recipe from John Hooks, who got it from a Mexican immigrant in the 1930s. Made of corn meal and meat, tamales were a popular staple of migrant workers in the Delta. Barbara Pope, Joe's sister, inherited the café in 2004.

Three

GHOST SIGNS AND RESTORED SIGNS OF MISSISSIPPI

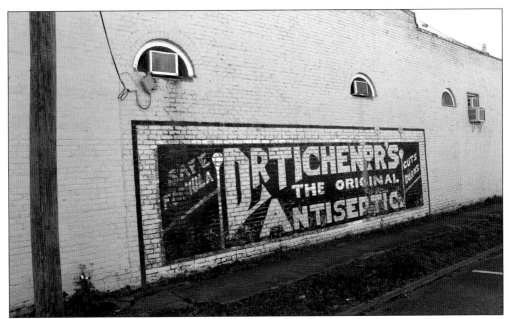

DR. TICHENOR'S GHOST SIGN, MACON, 2018. Ghost signs are faded, hand-painted advertisements primarily done on brick on the sides of buildings. Most of these signs that remain untouched over time are kept for nostalgia. Many were originally painted in the late 1890s through the 1960s using oil-based paints. Paints that survived the longest were usually lead-based. Severely damaged or faded ghost signs can be restored and preserved through re-painting.

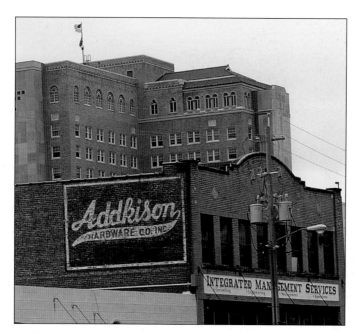

ADDKISON HARDWARE, JACKSON, 2017. Jackson businessman Robert Emmett Addkison opened Addkison Hardware in 1925 on East Capitol Street, later moving to East Pearl Street. In 1958, the store opened in the Berbette Building, erected in about 1927, on East Amite Street. The building was a former location of several furniture stores. Henry Muller Addkison Jr. operated the store from 1958 until its closing in 2001. The building is now the location of IMS Engineers.

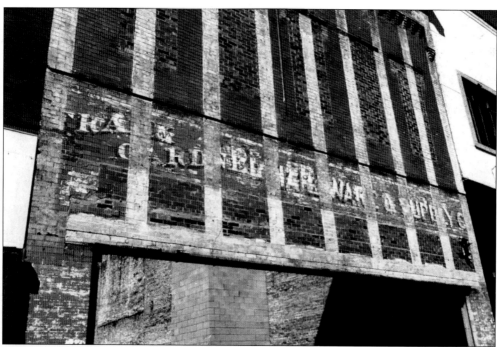

GARDNER HARDWARE AND SUPPLY, LAUREL, 2021. Gardner Hardware and Supply Co. was founded by Frank Gardner in the early 1900s on North Magnolia Street. A 1905 *Laurel Ledger* advertisement for the store states, "Hardware of every description from a horse-shoe nail up. We handle brick, lime, cement and everything needed by contractors and builders. Our line is the most complete on the North Eastern railroad south of Meridian. We guarantee our prices and goods."

BURR BROWN BUILDING, JACKSON, 2017. Burr Brown was an African American real estate businessman and railroad engineer who owned rental houses and commercial property in Jackson. The Burr Brown Building, built around 1938, is on Farish Street, Mississippi's largest independent African American cultural, economic, and political community in the mid-20th century. Farish fell into disrepair with integration in the 1960s, which harmed black-owned businesses in the district.

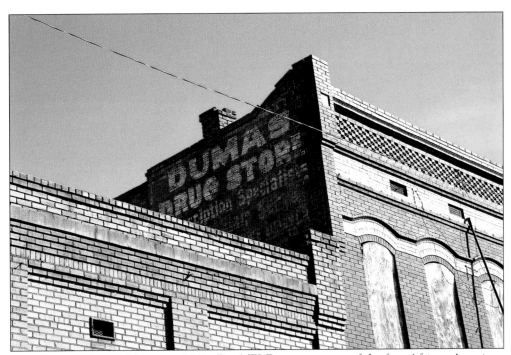

DUMAS DRUG STORE, NATCHEZ, 2018. Dr. A.W. Dumas was one of the first African American physicians in Natchez. Dumas Drug Store on Franklin Street was home to his medical practice and pharmacy and was a center for the African American business community. Dr. Dumas and his two sons operated the practice for 44 years. Dr. Dumas was a co-founder of the Mississippi Medical and Surgical Association and president of the National Medical Association.

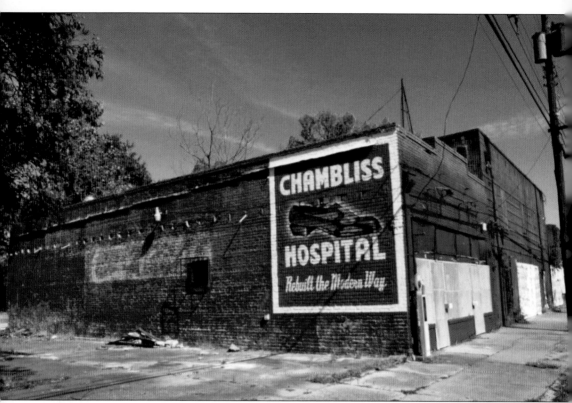

CHAMBLISS BUILDING, JACKSON, 2021. The lone four buildings on the 900 block of John R. Lynch Street in Jackson are all that remain of a once bustling African American business district. The Chambliss Shoe Hospital in the Chambliss Building, built around 1936, was operated by Jesse R. Chambliss Sr. from 1936 to the early 1970s. Chambliss, a community and business leader, kept extensive records providing insight into his life as a businessman during those years. He was a founding member of the Jackson Negro Chamber of Commerce and State Mutual Savings and Loan, and organized Jackson's first African American Boy Scout troop. The Chambliss Building is listed in the National Register of Historic Places and is a Mississippi historic landmark. The painted sign was restored in 2020 by Jackson artist Sabrina Howard.

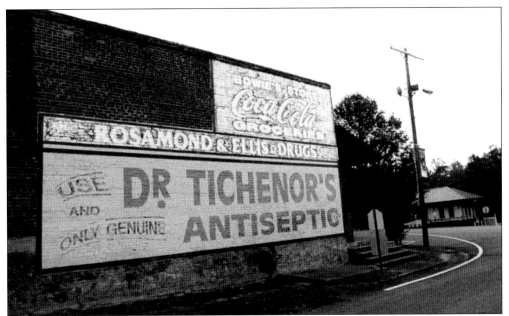

Dr. Tichenor's Signs, West, 2021 (above); and Lambert, 2022. While still in use primarily as a mouthwash and antiseptic, early advertising promoted Dr. Tichenor's as a cure-all for headaches, wounds, cramps, nausea, and indigestion. Dr. George Humphrey Tichenor, born in Kentucky in 1837, is believed to have introduced the antiseptic for his wounds while in the Confederate army during the Civil War. He developed his formula in Canton and Liberty before establishing the Dr. G.H. Tichenor Antiseptic Company in New Orleans in 1905. The only addition to the formula through the years has been a strong peppermint taste. An 1894 *Grenada Sentinel* advertisement states, "Dr. Tichenor's Antiseptic: For wounds, burns, sprains, etc. has no equal. If you will buy it, and fairly try it, your voice you'll raise, to speak its praise."

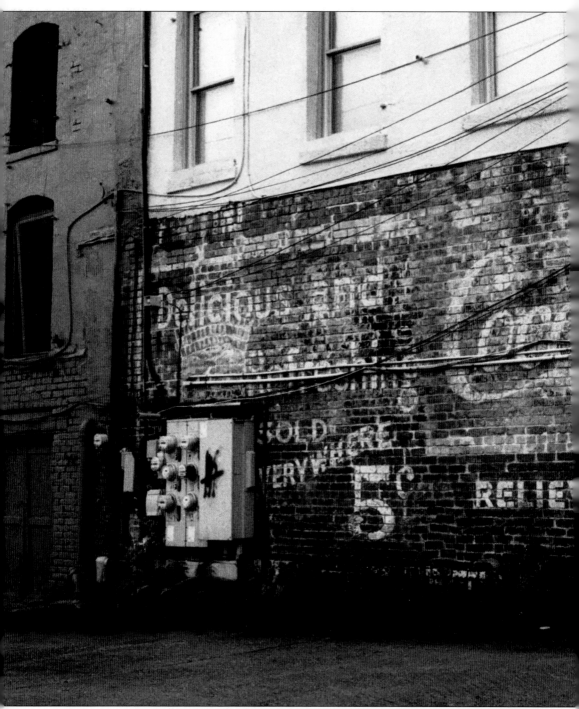

COCA-COLA GHOST SIGN, McCOMB, 2017. In 1886, Coca-Cola was invented by Dr. John Pemberton, a pharmacist from Atlanta. Pemberton developed a fragrant, caramel-colored liquid, which became the syrup for Coca-Cola. It was first sampled at Jacob's Pharmacy in Atlanta and found to be "excellent." The syrup was combined with carbonated water to create a new "Delicious and Refreshing" drink. Coca-Cola was first sold to the public at the soda fountain at Jacobs's

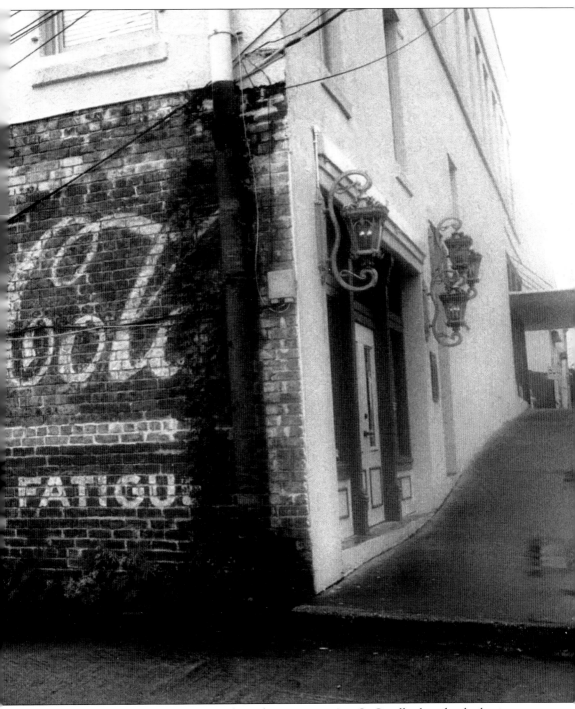

Pharmacy on May 8, 1886. In 1887, Atlanta businessman Asa G. Candler bought the business rights for Coca-Cola from Pemberton for $2,300, which was finalized by 1891. The Coca-Cola Company was founded by Candler in 1892. By the late 1890s, Coca-Cola was one of America's most popular fountain drinks, largely due to Candler's aggressive marketing.

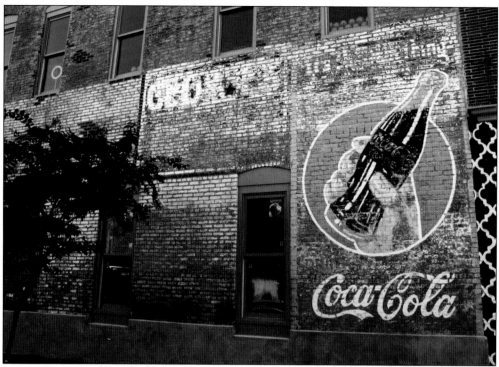

Coca-Cola Signs, Tupelo (above); and Yazoo City, 2017. Asa Griggs Candler was a genius in modern advertising and marketing. The Coca-Cola Company founder was responsible for the prominent placement of the Coca-Cola name everywhere in the early 20th century. Coca-Cola was on the sides of buildings, calendars, clocks, trays, and print advertisements. He enticed customers by creating the first-ever coupons for free glasses of Coca-Cola. He enlisted actress Hilda Clark as the first celebrity product endorser. Candler sold Coca-Cola at the fountain for 5¢ cents in 1886, a price the company kept for over 70 years. "Drink Coca-Cola, 5¢" was seen on building walls across the country. In 1916, the distinctive, contoured Coca-Cola bottle was introduced to distinguish itself from competitors. Candler sold the Coca-Cola Company for $25 million in 1919.

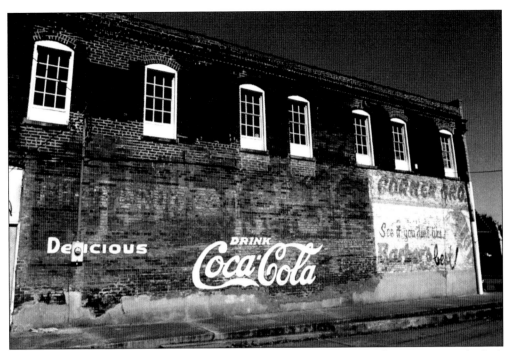

Coca-Cola signs, Pontotoc (above); and Stewart, 2019. Frank M. Robinson is an overlooked, yet equally important architect in the early history and marketing of Coca-Cola. On arrival in Atlanta from Maine in December 1885, Robinson went into partnership with John Pemberton, naming the new syrup after two of its ingredients: the coca leaf and kola nut. Changing the "K" to "C" for uniformity, and inserting a hyphen, he wrote the label in Spencerian script that would become one of the most recognized trademarks in history. He believed the script would look good in advertising. The first known use of the Coca-Cola logo was printed in block lettering in an advertisement on May 29, 1886. The Atlanta newspaper advertisement read, "Coca-Cola. Delicious! Refreshing! Exhilarating!, Invigorating!, The New and Popular Soda Fountain drink, containing the properties of the wonderful Coca plant and famous Cola nuts."

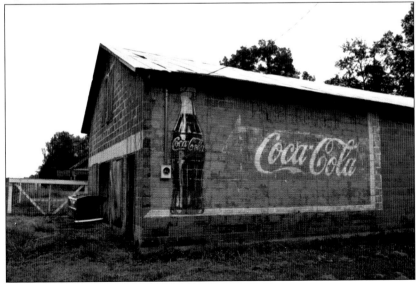

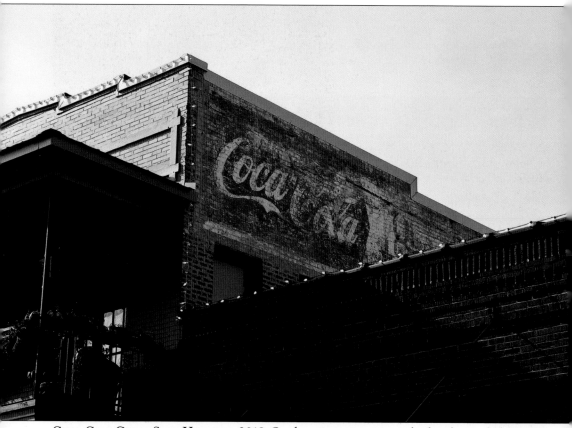

COCA-COLA GHOST SIGN, HOUSTON, 2018. Outdoor signs were among the first forms of advertising for Coca-Cola. In 1886, an oil-cloth banner was attached to an awning at Jacob's Drugstore in Atlanta that read "Drink Coca-Cola 5¢." By 1914, over 5 million square feet of Coca-Cola sign space was created across the country. Through the decades, Coca-Cola advertising has been successful in capturing the mood of the public. The slogan "Delicious and Refreshing," first introduced in 1904, continued into the 1920s. The Roaring Twenties was the beginning of consumer culture, when the same products were being sold nationwide. During this time, Coca-Cola advertisements were presented with a more direct message. In 1922, Coca-Cola added the slogan "Thirst Knows No Season," followed by "Refresh Yourself" in 1924. The popular phrase "The Pause That Refreshes," introduced in 1929, was the primary slogan for 30 years.

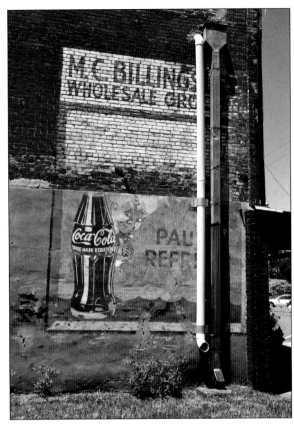

SPRITE BOY COCA-COLA SIGNS, WINONA (RIGHT); AND HOLCOMB, 2019. The elfish smile of Sprite Boy first appeared in advertisements for Coca-Cola in 1942. Sprite Boy was the first promotional image associated with the brand in an effort to help consumers identify the term Coke with Coca-Cola. Sprite Boy was illustrated by Haddon Sundblom, creator of the Coca-Cola Santa Claus. The character was portrayed as a head and hands that wore a bottle cap for a hat. Sprite Boy was on all forms of Coca-Cola signage and promotional items from 1953 until being phased out in 1958. In 1961, the soft drink Sprite was introduced by Coca-Cola as a competitor to 7-Up.

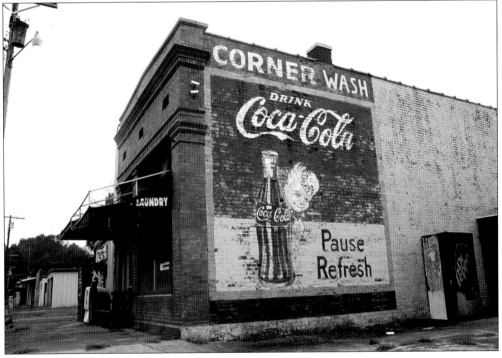

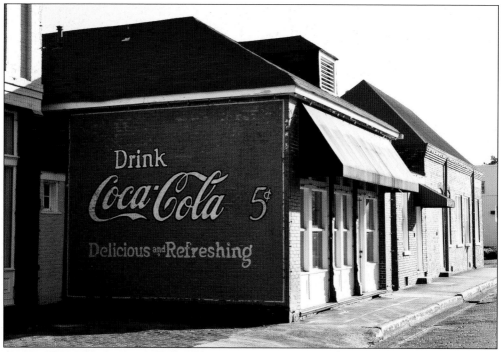

COTTON ROW, GREENWOOD, 2019. The century-old buildings lining Front Street in Greenwood were known as "Cotton Row." This was Mississippi's most important concentration of buildings associated with the marketing of cotton. Located along the Yazoo River, the buildings once housed offices in which buying, grading, and selling of cotton took place into the 1970s. The Viking Corporation, headquartered on Cotton Row since 1987, has occupied and renovated much of the district.

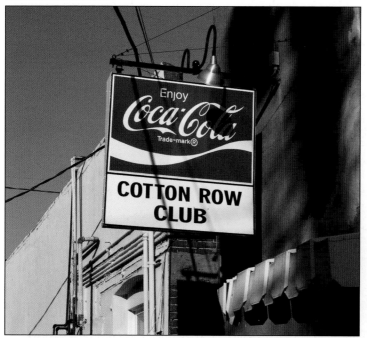

COTTON ROW CLUB, GREENWOOD, 2019. The Cotton Row Club dates back to the height of the cotton industry in the early to mid-20th century in Greenwood. Located on Ramcat Alley between Front and Market Streets, cotton buyers and farmers gathered in this converted stable and blacksmith building constructed in 1910. The late Rev. L.V. "Hambone" Howard, a legendary Greenwood personality, had a shoeshine stand at the club for over 25 years.

GHOST SIGNS, COLUMBUS, 2019. Advertisements painted on the sides of buildings were done by "wall dogs," commercial sign painters who created external signs and murals across the country from the 1890s into the 1960s. Wall dogs were commissioned by businesses to paint large advertisements to promote the company's products and services. The term is attributed to the vast amount of time the sign painters would spend on ladders and scaffolding. Wall paints had to survive winter and summer weather conditions and were typically a combination of linseed oil, pigments, "driers" like benzene or gasoline, and lead for durability. The 1920s through the 1940s were considered the golden age of wall advertising.

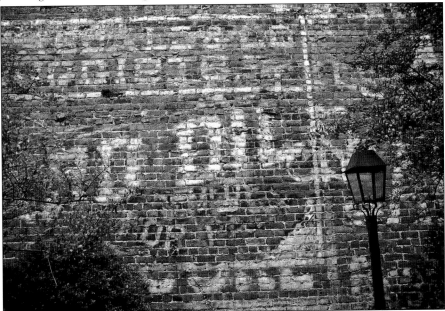

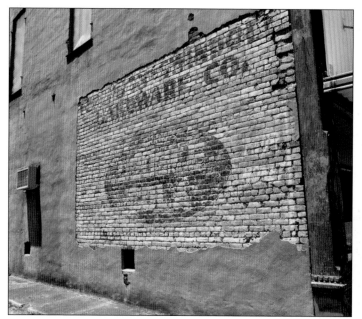

Double-Cola Ghost Sign, Winona, 2019. Double-Cola was the original "super-sized" soft drink. The beverage traces its roots to The Good Grape Co., founded in 1922 by Charles D. Little and Joe S. Foster. With the creation of Marvel Cola in 1924, the company changed its name to Seminole Flavor Company. Marvel Cola was changed and renamed Jumbo Cola. In 1933, the cola was sold in 12-ounce bottles, twice the size of other soda bottles at the time, and named Double-Cola.

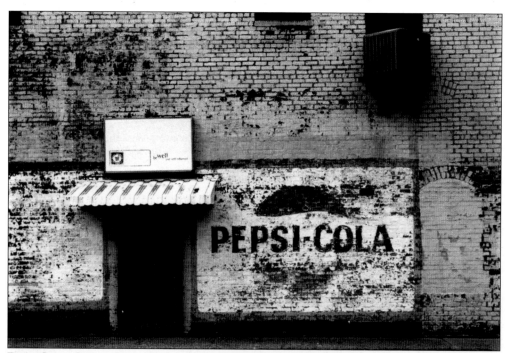

Pepsi-Cola Ghost Sign, Hollandale, 2021. Pepsi-Cola was invented in 1893 by Caleb D. Bradham, a pharmacist in New Bern, North Carolina. First introduced as "Brad's Drink," it was renamed Pepsi-Cola in 1898, hoping to duplicate the success of Coca-Cola. In 1902, Bradham incorporated the Pepsi-Cola Company. In 1934, the company introduced a 12-ounce bottle, nearly twice the size of Coca-Cola. "Pepsi Hits the Spot" was a popular advertising slogan from the 1930s to the late 1950s. The name was shortened to just Pepsi in 1961.

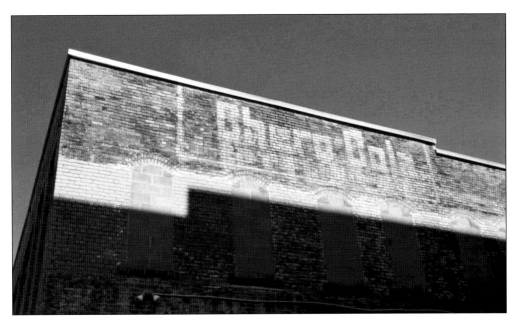

CHERO-COLA SIGN, LAUREL, 2021; AND RC COLA SIGN, GREENWOOD, 2019. After a dispute with Coca-Cola over wholesale pricing, Claud A. Hatcher, a pharmacist from Columbus, Georgia, founded the Union Bottling Works. The company began making Royal Crown Ginger Ale in 1905. Chero-Cola, a cherry-flavored cola, was introduced in 1907. The company was renamed Chero-Cola in 1912 to compete with Coca-Cola. In 1920, Coca-Cola sued for trademark infringement, forcing Chero-Cola to drop the name "cola" in 1923. With the name change, a decline in market share forced Chero-Cola to be discontinued in 1924. Chero-Cola added Nehi, a fruit-flavored beverage, in 1924 and changed the company name to Nehi Inc. in 1928. The company re-entered the cola business with Royal Crown, or RC Cola, in 1934. Nehi became the Royal Crown Company in 1951. Royal Crown was the first to manufacture nationally available canned sodas in 1954.

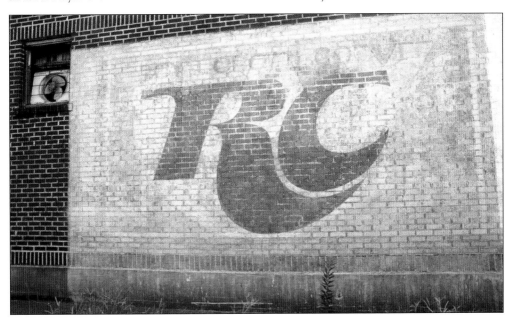

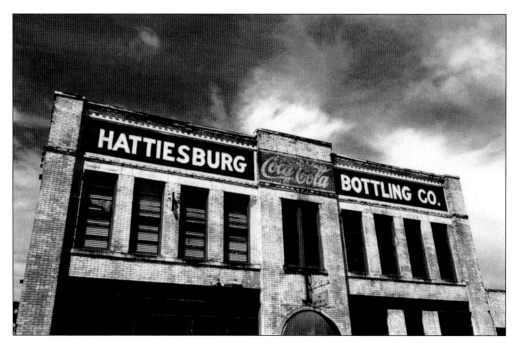

HATTIESBURG COCA-COLA BOTTLING COMPANY, HATTIESBURG, 2019. Over a century of bottling tradition exists between the Coca-Cola Company and Hattiesburg. The Hattiesburg Coca-Cola Bottling Co. opened in 1906 on Second Street and expanded to this larger location in 1915 on Market Street, now Mobile Street. The company was owned by the Thomson family for 86 years, with W.A. Thomson managing it from 1921 to 1967. Operating through two world wars, the plant ran 24 hours a day to supply Camp Shelby during World War II. In 1955, the company relocated to a new plant on Highway 49 and later to the current location on Coca-Cola Avenue. The historic building, constructed around 1910, is now the Bottling Company, an event venue.

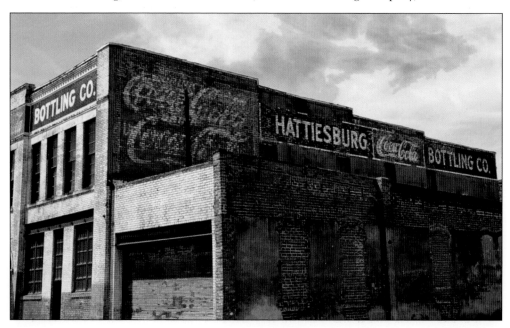

CORINTH COCA-COLA BOTTLING GROUP, CORINTH, 2022 (ABOVE); AND 2018. For nearly 120 years, the Corinth Coca-Cola Bottling Group has been operated by generations of the Weaver family. In 1905, Avon Kenneth Weaver bought an interest in the Corinth Bottling Works, a soda water plant owned by C.C. Clark. The first operation consisted of four workers. Early equipment was basic, with bottles washed and filled by hand. Bottles were capped with a foot-powered machine. Weaver and Clark were awarded a franchise by the Coca-Cola Bottling Company of Chattanooga, Tennessee, in 1907, forming the Coca-Cola Bottling Group of Corinth. The company now serves 40 counties in Mississippi, Tennessee, Arkansas, and Missouri.

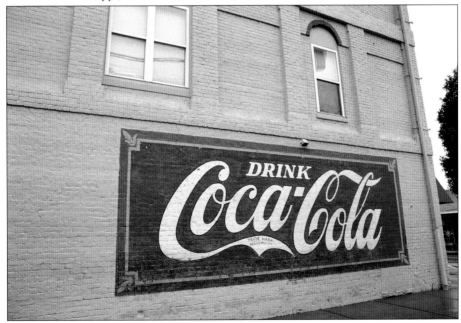

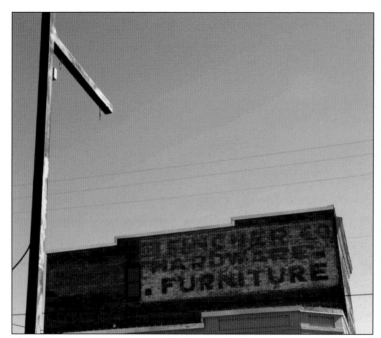

FINCHER HARDWARE, LEXINGTON, 2021. Fincher Hardware was opened by William Henry Fincher II in the early 20th century on the square in Lexington. His son William Henry Fincher III, a World War II Army veteran, took over the business when his father retired in 1945. A lifelong Holmes County resident, Fincher III was the owner until he retired in 1981.

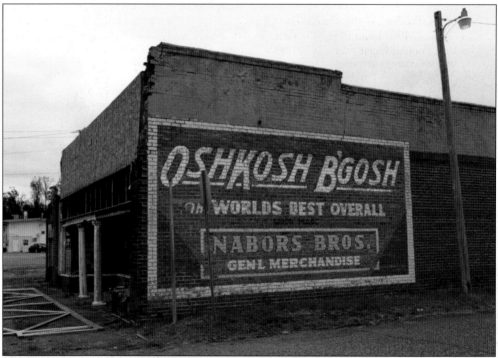

NABORS BROTHERS GENERAL MERCHANDISE, SMITHVILLE, 2019. Oshkosh B'Gosh, advertised in this sign by Nabors Brothers General Merchandise, was founded in 1895 as Grove Manufacturing Company, makers of hickory-striped bib overalls worn by railroad workers and farmers. Based in Oshkosh, Wisconsin, the company became Oshkosh B'Gosh in 1937, although the company started calling its bibs "Oshkosh B'Gosh" as early as 1911. Legend attributes the name to William Pollock, a former owner, who heard the phrase in a New York vaudeville skit.

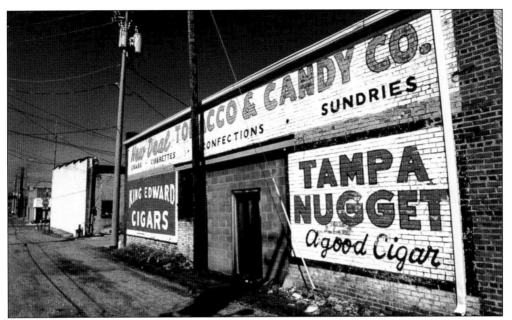

NEW DEAL TOBACCO & CANDY COMPANY, GREENWOOD, 2017. New Deal Tobacco & Candy Company was a wholesale distributor of candies and tobacco. Owned and operated by the Cascio family, the business was open in Greenwood from 1937 to 1991. It also had a warehouse in Greenville. A 1950 *Delta Democrat Times* advertisement reads, "Tampa Nugget Cigars, Good As Gold, At Popular Cigar Stores, Distributed by New Deal Tobacco and Candy Company."

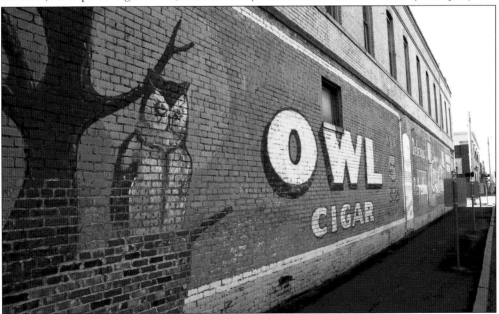

OWL CIGAR SIGN, WEST POINT, 2018. The Owl Cigar Company was established in 1890, reorganized from the Straiton & Storm Co., one of the largest US cigar manufacturers. To grow the market beyond New York, the company launched the painted advertising program "Owl Cigar – Now 5 CTS." Advertisements with the iconic owl were painted on buildings and barns by wall dogs across the country. This restored sign is on East Main Street in West Point.

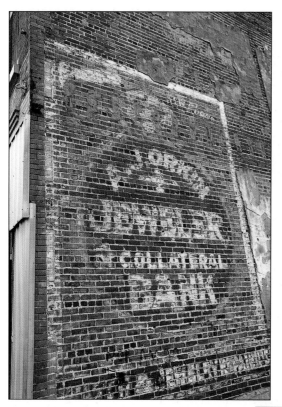

A.J. Orkin Jeweler & Collateral Bank Sign, Jackson, 2017 (left); and 2021. When the McRae's building on West Capitol Street was demolished in the 1980s, a painted sign for A.J. Orkin Jeweler & Collateral Bank was exposed after being sealed away under the plaster on the building next door. Adolph "A.J." Orkin was a jeweler and pawnbroker with a repair shop on Capitol Street in the early 20th century. The sign had been protected for decades from the sun and weather. Downtown Jackson Partners had the century-old sign restored in 2018 by A Plus Signs and Creative. An environmentally friendly version of the original oil-based paint, which contained lead, was used to restore the sign. Although these faded signs are of local cultural and commercial history, there has been debate over restoring them or allowing for gradual weathering.

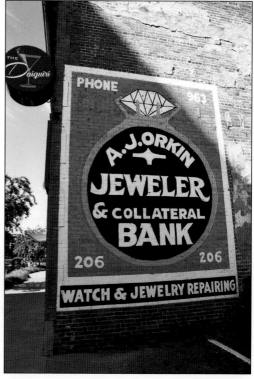

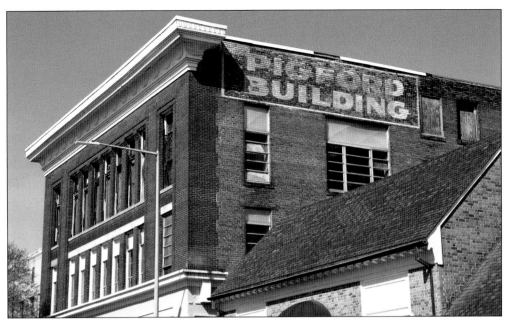

PIGFORD BUILDING, MERIDIAN, 2022. The Pigford Building was built around 1915 as the Pythian Castle Hall by Mount Barton Lodge No. 13, Knights of Pythian. In the 1920s, the building was bought by Pigford Realty. Businesses in the building included Jitney Jungle grocery store, restaurants, beauty salons, dress shops, and a drugstore/post office. According to legend, the building is haunted by apparitions.

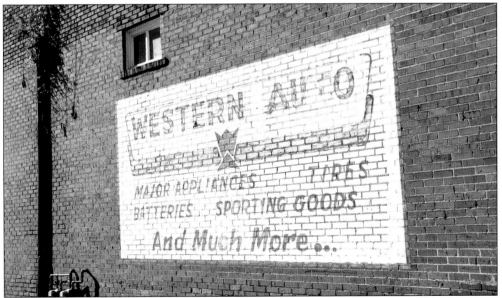

WESTERN AUTO SIGN, PHILADELPHIA, 2018. Western Auto was a national chain in auto parts, appliances, and bicycles and a pioneer in franchising. Founded in 1909 in Kansas City, Missouri, as a mail order business by George Pepperdine, founder of Pepperdine University, and Don Abnor Davis, its first retail store was opened in 1921. At its peak, there were 1,200 company and 4,000 franchise stores. Western Auto was sold to Beneficial Corporation in 1961, then eventually to Sears, which ultimately sold Western Auto to Advance Auto Parts in 1998.

Saxton Hardware, Yazoo City, 2017. Walter M. Saxton opened Saxton-Gardner Hardware Co. in 1933 on South Main Street in Yazoo City. His son Walter C. Saxton, followed by grandson Walter P. Saxton, continued the family tradition at the now-closed business. The historic Saxton Hardware building, built around 1904, was also the location for Crane-Hamel Hardware before Saxton in the early 20th century. Crane Brothers and Co. was established in 1883 in Yazoo City.

Sturdivant-Smith, Winona, 2019. Sturdivant-Smith Hardware and Furniture was established in 1919 by O.W. Sturdivant and B.D. Smith on Front Street in Winona. In 1925, Sturdivant bought the interest of Smith, continuing the business in the name of O.W. Sturdivant. The store sold rugs, tires, wagons, refrigerators, coffins, heaters, fans, sporting goods, and sewing machines. A 1920 advertisement states, "Coal and Drayage, Good Teams and Wagons, Prompt Service."

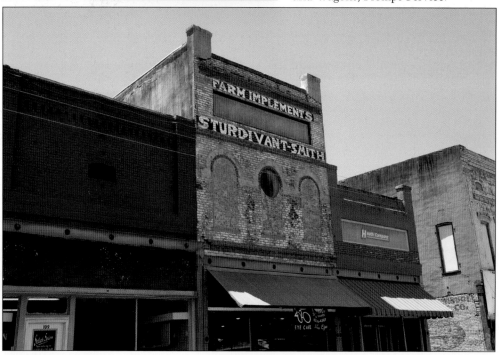

SENTER DRUG COMPANY, FULTON, 2017. The vintage Dr Pepper painted advertisement at Senter Drug Company has been a familiar greeting for generations of residents in Fulton. Founded by Dr. John Senter in the early 1920s, the drugstore with soda fountain was a longtime gathering place for Itawamba County residents. The repainted sign from the 1940s features the popular Dr Pepper slogan "Drink a Bite to Eat at 10, 2, and 4 o'clock."

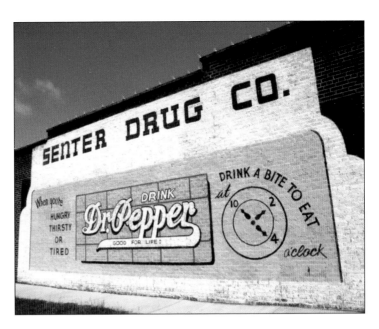

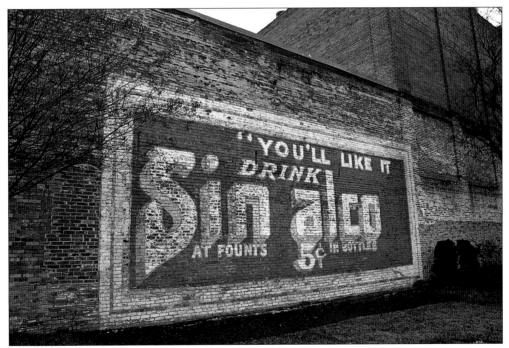

SINALCO SIGN, CORINTH, 2018. Sinalco is the oldest soft drink brand in Europe. Sold in over 40 countries, the beverage is produced by Sinalco International in Duisberg, Germany. Invented in 1902 by German scientist Friedrich Eduard Bilz as a sherbet powder called Bilz Brause, it was Europe's first nonalcoholic international beverage brand. In 1905, a contest was held for a brand name, choosing Sinalco, an abbreviation for the Latin *sine alcohole*—"without alcohol." This sign is on the side of the Corinth Coliseum Theatre.

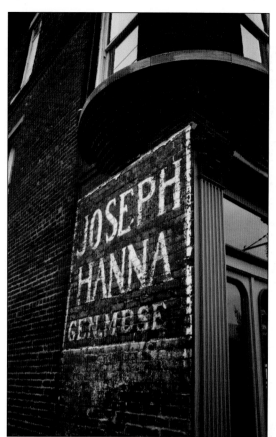

JOSEPH HANNA GENERAL MERCHANDISE, COLUMBUS, 2019. Joseph Hanna was a Turkish immigrant who operated Hanna and Thelgie Dry Goods in 1922 on Main Street in Columbus. The business became Joseph Hanna Dry Goods in the 1920s. The longtime Columbus store was known for shoes, notions, dry goods, and clothing. Born in 1897, Hanna passed away in 1983.

KRAMER ROOF BUILDING, MCCOMB, 2018. All that remains of the partially collapsed Kramer Roof Building, built around 1920, is a section with overlapping ghost signs of the building's original occupants, the McComb State Bank & Trust Co. and Jacob's Theatre. It was also the location for J.C. Penney, a performing arts studio, and a church. The Falstaff Beer sign is a reminder of the brand at its height of popularity during the 1950s and 1960s. The McComb landmark collapsed in 2017.

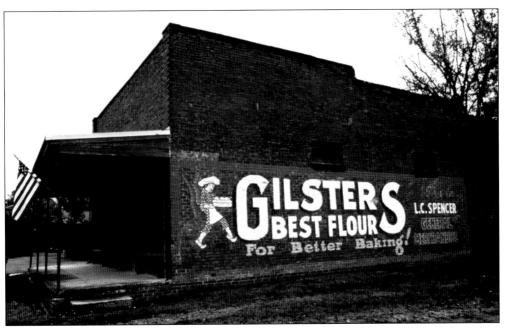

GILSTER'S BEST FLOUR SIGN, McCARLEY, 2018. This repainted sign advertises Gilster's Best Flour and L.C. Spencer General Merchandise in Carroll County. Louis Spencer opened the store in 1896 and sold to Frank Loper in 1941, renaming it the F.E. Loper Grocery. The Gilster Milling Company was founded in 1895 to produce soft wheat flour in Steeleville, Illinois, when scratch baking was common in America. Gilster's Best was popular in Mississippi, Alabama, and other parts of the South.

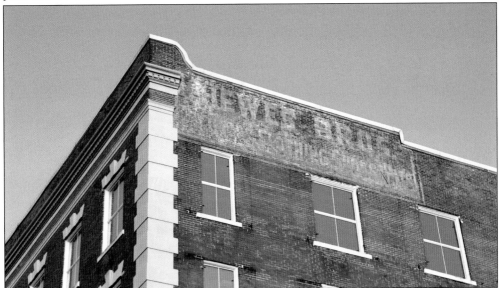

HEWES BUILDING, GULFPORT, 2019. Constructed in 1905, the five-story Hewes Building was an early Mississippi mid-rise, built during the timber industry boom in southern Mississippi in the early 20th century. The building is believed to have operated the first elevator in Mississippi and is listed in the National Register of Historic Places. Gulfport was incorporated in 1898 to connect inland lumber mills to the coast.

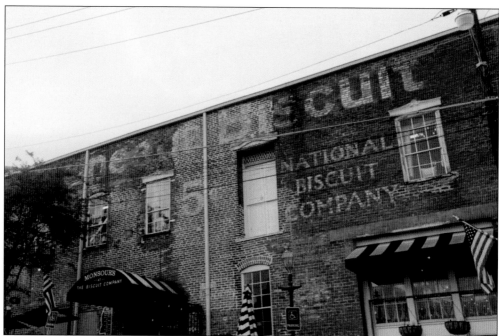

UNEEDA BISCUIT SIGNS, VICKSBURG, 2017 (ABOVE); AND MERIDIAN, 2022. The National Biscuit Company was founded in 1898 in a merger between American Biscuit and Manufacturing, New York Biscuit, and the United States Baking Company, and was later called Nabisco. Uneeda Biscuit was the National Biscuit Company's first packaged cracker, and among the first ever sold in a package. Working with advertising agency N.W. Ayer of New York, founder A.W. Green picked the name Uneeda Biscuit. Green kept the price at a nickel a package. He came up with the trademark and logo for the company from an old Venetian printer's mark, an oval with a double cross. The name Nabisco first appeared on a sugar wafer in 1901, but the company name did not change until 1971. Nabisco merged with Standard Brands in 1981 and was bought by R.J. Reynolds in 1985. Uneeda was discontinued in 2008.

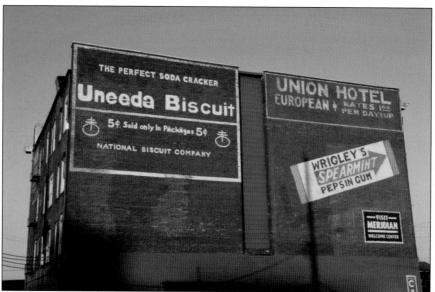

Four

Theater Signs
of Mississippi

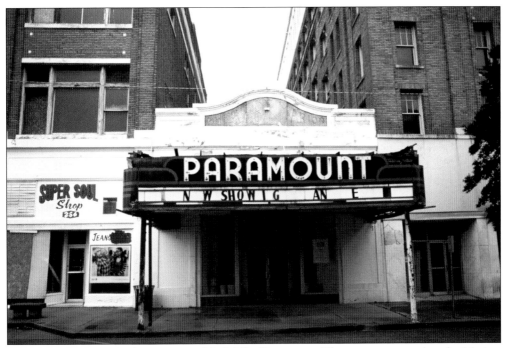

Paramount Theatre, Clarksdale, 2019. The Paramount Theatre was opened as the Marion Theatre in Clarksdale in 1918. Designed by John Gaisford, the theater was one of the first in the area built primarily for movies. The Marion was acquired by Saenger Amusements in 1931 and renamed the Paramount. Open until 1976, it became a venue for the performing arts in 1986. It was designated a Mississippi landmark in 1986 and listed in the National Register of Historic Places in 2009.

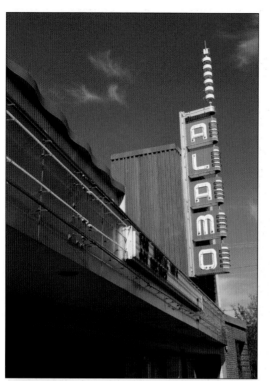

ALAMO THEATRE, JACKSON, 2021. The Alamo Theatre is an African American cultural landmark on Farish Street. Opened in 1949 by Arthur Lehman, the theater was built as a dual-purpose cinema and performing arts center. The Alamo had two previous locations before Farish. Nat King Cole, B.B. King, Elmore James, Louis Jordan, and Jackson's Dorothy Moore performed here. The Alamo closed in 1983. In 1997, the theater reopened after a two-year renovation, including the restoration of the original neon sign and marquee.

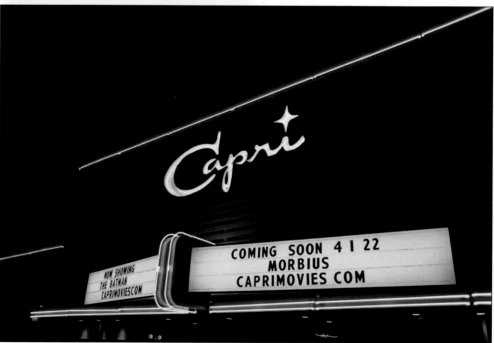

CAPRI THEATRE, JACKSON, 2022. The Capri Theatre, designed by Jackson's Jack Canizaro, opened in 1940 as the Pix Theatre in the Fondren District. The Pix closed in 1957 and reopened as the Capri in 1962. The Capri closed in 1986 and was reopened after a major renovation project in 2022. The sign was installed for production of the 2011 movie *The Help* and restored in 2021.

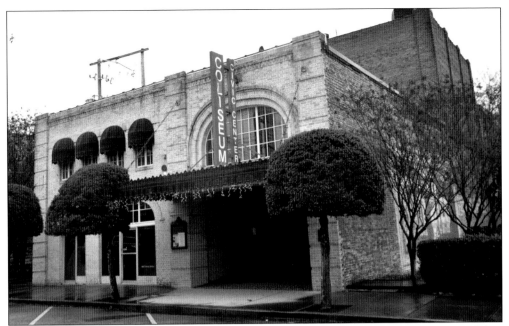

COLISEUM THEATRE, CORINTH, 2018. For nearly a century, the Coliseum Theatre in Corinth has been entertaining audiences in northeast Mississippi. The theater was first built at the current location in 1913 for silent movies by Benjamin F. Liddon. In 1924, he replaced the original theater with the Coliseum Theatre, a vaudeville and movie venue. It continued into the mid-1970s for movies and was restored in the 1980s.

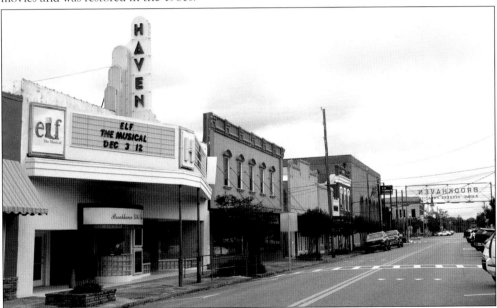

HAVEN THEATRE, BROOKHAVEN, 2021. The Haven Theatre, believed to be built around 1925, is said to be the second oldest theater in Mississippi still used for the performing arts. Jack E. Sarphie opened the Sarphie Theatre in 1931. In 1935, the theater was sold, and the name changed to the Haven. It was remodeled after World War II to the current layout, with a neon sign from a 1950 renovation. Brookhaven Little Theatre bought the building in 1983.

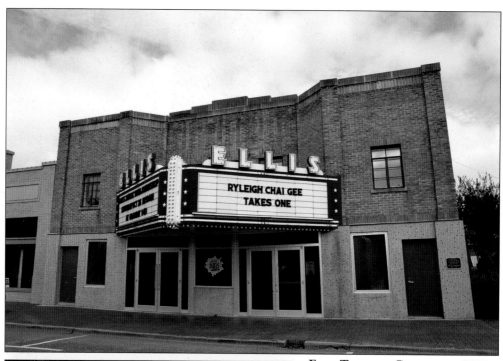

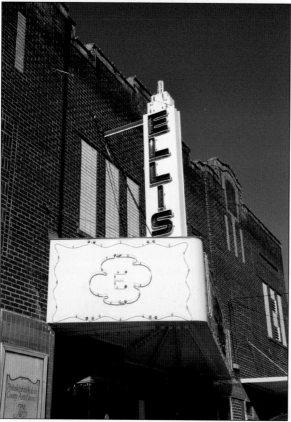

ELLIS THEATER, CLEVELAND, 2019.
W.T. Ellis arrived in Cleveland in 1916, where he opened a drugstore and showed movies in a tent downtown in the 1930s. He constructed the Ellis Theater on Court Street in 1938, which was then known as the Regent Theater. C.J. Collier, the owner of several Delta theaters, bought the venue in the 1940s. The theater continued into the late 1970s and was sold to Rhodes Printing. Restored in 2010, the theater is owned by the Delta Arts Alliance.

ELLIS THEATRE, PHILADELPHIA, 2018. The Ellis Theatre is the centerpiece of a massive renovation project of the Marty Stuart Congress of Country Music. The project includes the Ellis Theatre restored as a performance theater, museum, and multipurpose event space. The historic venue was opened as the City Theatre in 1926, became the Strand Theater in 1939, and was eventually renamed the Ellis.

ELKIN THEATRE, ABERDEEN, 2018. The Elkin Theatre was opened by the Elkin family as a movie theater in 1937. The venue became a Malco and Lyric theater. When movie operations were shut down in 1985, local families bought the building to continue operations and maintain historic preservation. Funds from movies, events, grants, and donations are reinvested for improvements to the historic building.

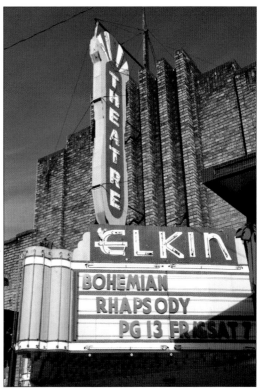

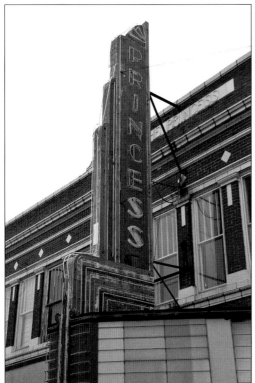

PRINCESS THEATRE, COLUMBUS, 2019. The Princess Theatre was built in 1924 as a vaudeville house and later became a movie theater. The 800-seat venue was previously operated by Malco Theatres, Paramount Pictures Inc., and Saenger Amusement Co. A 1939 program reads, "Lionel Barrymore and Excellent Cast In "On Borrowed Time," Opening Monday For Two Days At The Princess Theatre Here."

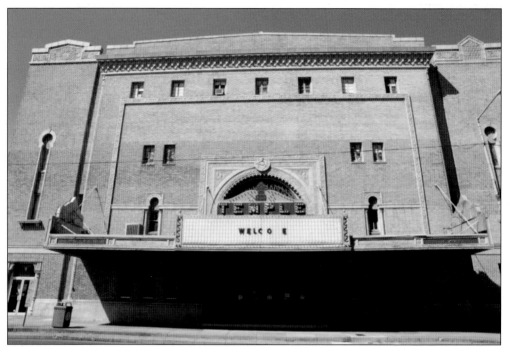

TEMPLE THEATRE, MERIDIAN, 2022. At the time of its completion in 1928, the Temple Theatre's stage was second in size only to the Roxy Theater in New York. Construction began in 1923 by the Hamasa Shriners and was designed in the Moorish Revival style by Emile Weil. In 1927, the Hamasa Shrine contracted with the Saenger chain to provide movies and live productions, which lasted over 40 years. The Temple's Robert Morton pipe organ, installed for the grand opening in 1928, is still in operation. In the 1970s, the Hamasa Shrine restored the building, but the contract with Saenger ended and the building fell into disrepair. Businessman Roger Smith bought the Temple in 2009 for live performance events. The list of performers includes Waylon Jennings, Bill Monroe, Willie Nelson, and George Strait.

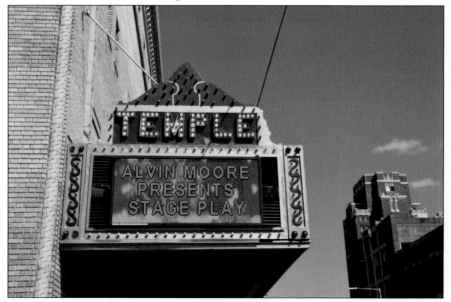

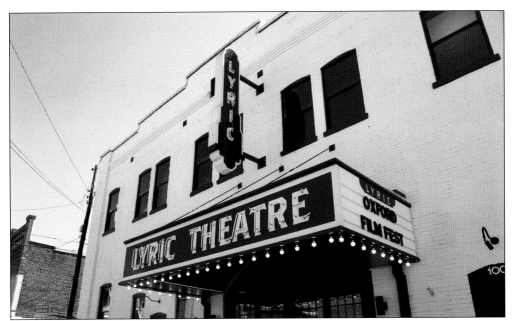

LYRIC THEATRE, OXFORD, 2022. The Lyric Theatre was Oxford's first movie theater, opened in 1914 for stage plays and silent movies. The building was originally a livery stable owned by William Faulkner's family in the early 20th century. Partially burned in 1924, it was restored by R.X. Williams. In the 1970s, the Lyric stopped operating for movies and was closed until the 1980s, when it was converted into office spaces. In 2007, the Lyric was restored as a performance venue.

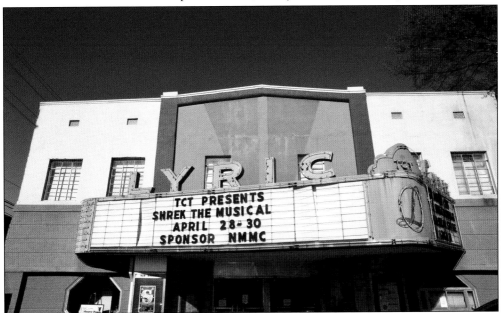

LYRIC THEATRE, TUPELO, 2022. A survivor of the devastating 1936 tornado, the Lyric Theatre was built in 1912 by R.F. Goodlett as the Comus Theatre for vaudeville shows. Renamed the Strand Theatre with the Saenger chain in 1924, it became the Lyric in the 1930s with the Malco chain. The theater continued with movies until 1984 when the Tupelo Community Theater bought and restored the building for live productions.

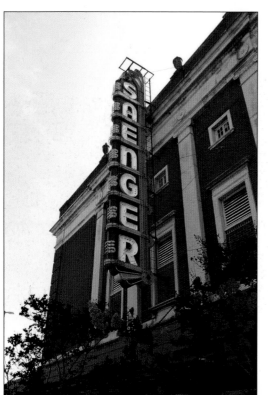

Saenger Theatre, Biloxi, 2019.
Welcomed as the "Gem of the Gulf Coast," the Saenger Theatre in Biloxi opened in January 1929. The theater was constructed by Julian and Abraham Saenger with the advent of sound films and large movie venues. It also hosted vaudeville and traveling shows. A fire closed the Saenger in 1974, and the building has seen several renovations. A duplicate of the original sign was installed in 2001.

Saenger Theatre, Hattiesburg, 2022.
The Saenger Theatre in Hattiesburg is one of Mississippi's few remaining examples of this type of movie palace. Opened on Thanksgiving Day 1929, the theatre was built by the Saenger brothers and designed by Emile Weil. Its original Robert Morton pipe organ was reinstalled in the 1980s and is still in use. ABC Interstate Theatres closed the facility to movies in 1974. In 2000, a large renovation restored the site for live performances.

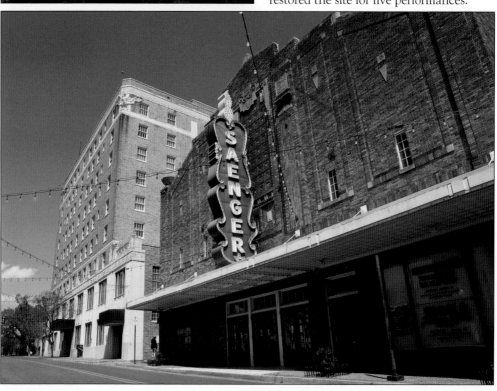

STATE THEATRE, STARKVILLE, 2019. Opened in 1937, the State was built by the owners of the Rex Theatre on the site of the original Rex, which burned down in 1929. The State was one of North Mississippi's oldest theaters and performing arts venues. In 2016, it was repurposed as the tavern Hobie's on Main.

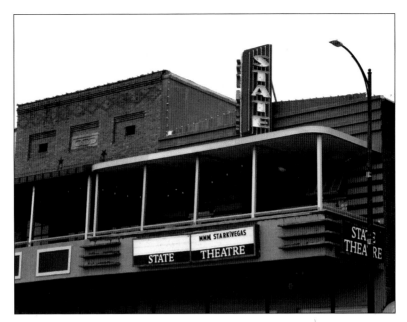

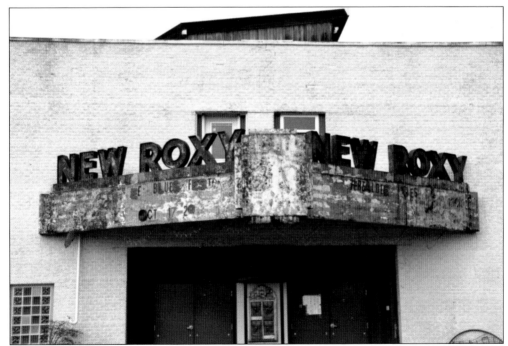

NEW ROXY THEATRE, CLARKSDALE, 2019. The New Roxy is a former movie theater in the New World District, the historic African American neighborhood in Clarksdale. The New Roxy was built around 1950 by A.N. Rossie, originally from Syria, and his wife, Sadie, from Louisiana, next door to the original Roxy, which was destroyed by fire in 1973. Closed in the mid-1980s, the deteriorated theater was bought by Robin Colonas and renovated in 2008 as an open-air venue.

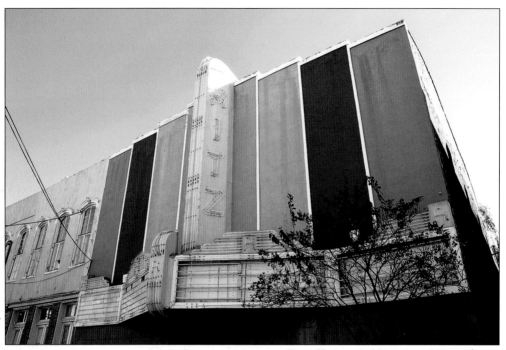

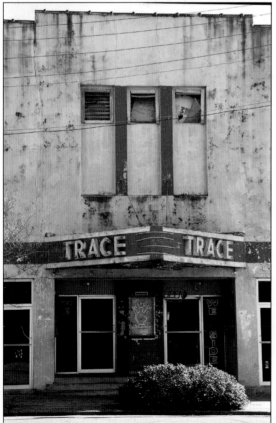

RITZ THEATRE, NATCHEZ, 2018. The Ritz Theatre was opened in 1935 by Louis Fry and Laz Abraham. In 1940, the Ritz was sold to Saenger Amusements, and again in 1950 to Jerry Oberlin, who sold to Irving Oberlin in 1953. The theater closed around 1970. The Historic Natchez Foundation acquired the Ritz in 2002, attempting to preserve the Art Deco structure. In 2021, Steve Campo and Mamie Henry acquired the building and converted it into a vendors' marketplace.

TRACE THEATER, PORT GIBSON, 2018. In 1945, the theater was rebuilt after a fire and continued until 1968 when another fire, allegedly by arson after the assassination of Dr. Martin Luther King Jr., permanently closed the cinema. The theater was owned by the Ewings of Fayette, who also owned the Fay Theatre in Fayette and the AutoVue Drive-In in Lorman. In 1989, it was home to the Cornerstone Theatre Company. A fire in 2020 completely destroyed the Trace.

BIBLIOGRAPHY

Allen, Frederick. *Secret Formula*. New York, NY: Open Road Integrated Media, Inc., 1994.

Baughn, Jennifer, V.O. Baughn, Michael W. Fazio, with Mary Warren Miller. *Buildings of Mississippi*. Charlottesville, VA: University of Virginia Press, 2020.

Cheseborough, Steve. *Blues Traveling: The Holy Sites of Delta Blues*. Jackson, MS: University Press of Mississippi, 2009.

Conforth, Bruce and Gayle Dean Wardlow. *Up Jumped the Devil: The Real Life of Robert Johnson*. Chicago, IL: Chicago Review Press, 2019.

Cuevas, John. *Lost Gulfport*. Charleston, SC: The History Press, 2018.

Davidson, June Davis. *Country Stores of Mississippi*. Charleston, SC: The History Press, 2014.

Dietz, Lawrence. *Soda Pop. The History, Advertising, Art and Memorabilia of Soft Drinks in America*. New York, NY: Simon and Schuster, 1973.

Eubanks, W. Ralph. *A Place Like Mississippi*. Portland, OR: Timber Press, Inc., 2021.

Flowers, Judith Coleman. *Clarksdale and Coahoma County*. Charleston, SC: Arcadia Publishing, 2016.

Jorgensen, Larry. *The Coca-Cola Trail: People and Places in the History of Coca-Cola*. Mansura, LA: GL Management LLC, 2017.

Ownby, Ted and Charles Reagan Wilson, eds. *Mississippi Encyclopedia*. Jackson, MS: University Press of Mississippi, 2017.

Palmer, Robert. *Deep Blues*. New York, NY: Penguin Books, 1982.

Pendergrast, Mark. *For God, Country, & Coca-Cola* (third edition). New York, NY: Basic Books, 2013.

The Delta: Landscapes, Legends, and Legacies of Mississippi's Most Storied Region. Cleveland, MS: Coopwood Publishing Group, 2013.

DISCOVER THOUSANDS OF LOCAL HISTORY BOOKS FEATURING MILLIONS OF VINTAGE IMAGES

Arcadia Publishing, the leading local history publisher in the United States, is committed to making history accessible and meaningful through publishing books that celebrate and preserve the heritage of America's people and places.

Find more books like this at
www.arcadiapublishing.com

Search for your hometown history, your old stomping grounds, and even your favorite sports team.